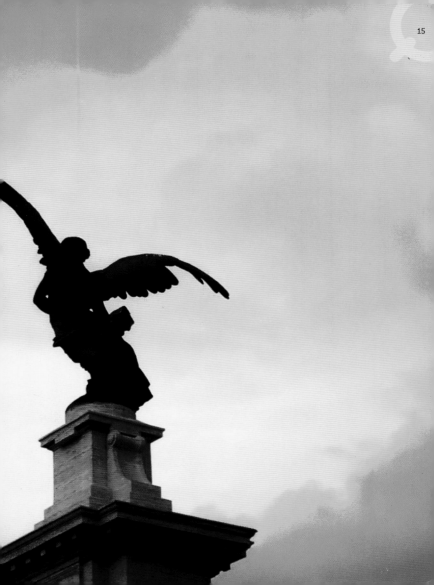

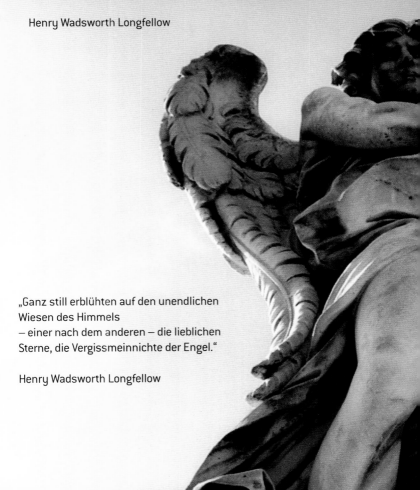

"Silently one by one, in the infinite meadows of heaven
Blossomed the lovely stars, the forget-me-nots, of angels."

Henry Wadsworth Longfellow

„Ganz still erblühten auf den unendlichen
Wiesen des Himmels
– einer nach dem anderen – die lieblichen
Sterne, die Vergissmeinnichte der Engel."

Henry Wadsworth Longfellow

« En silence, une à une, dans les prairies infinies
du paradis
Fleurirent les belles étoiles, les myosotis
des anges. »

Henry Wadsworth Longfellow

"Stil, een voor een, in de oneindige hemelse weilanden
Bloeiden de mooie sterren, de vergeet-mij-nietjes
van de engelen."

Henry Wadsworth Longfellow

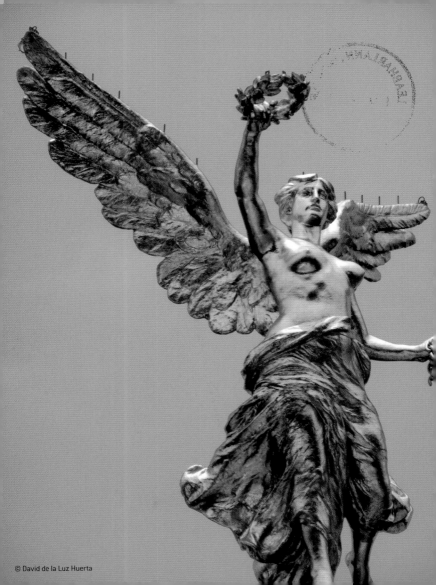

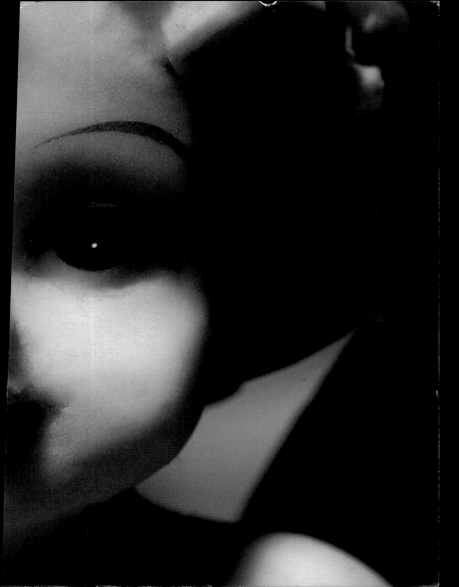

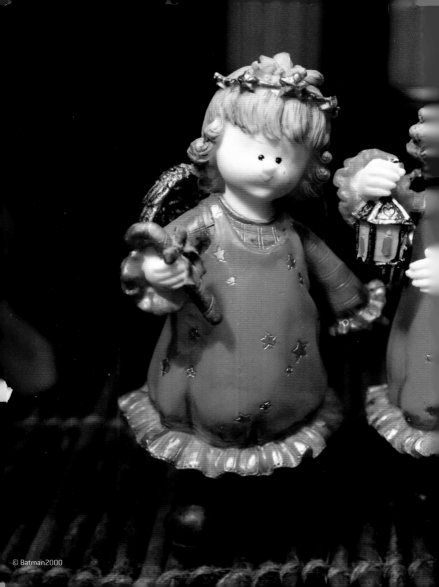

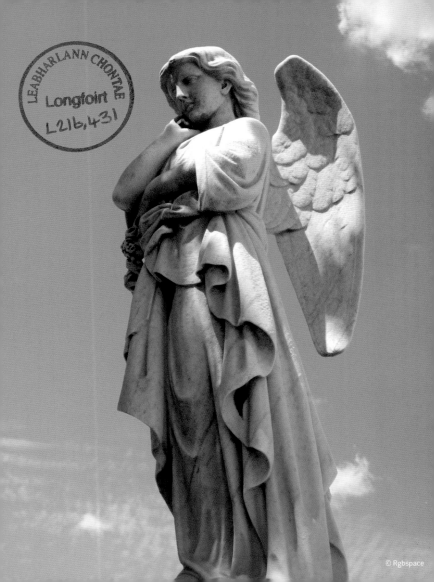

© Rgbspace

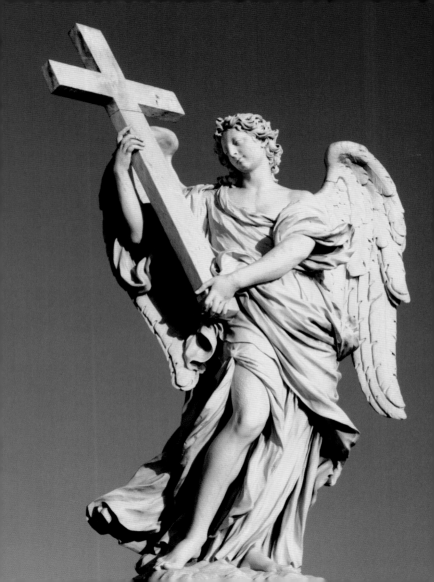

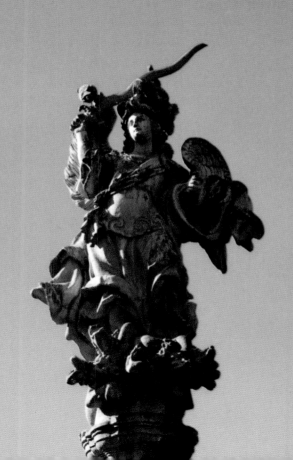

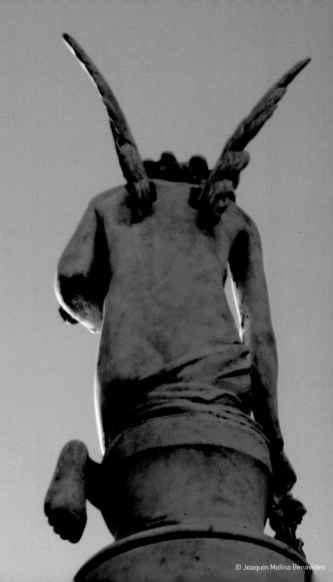

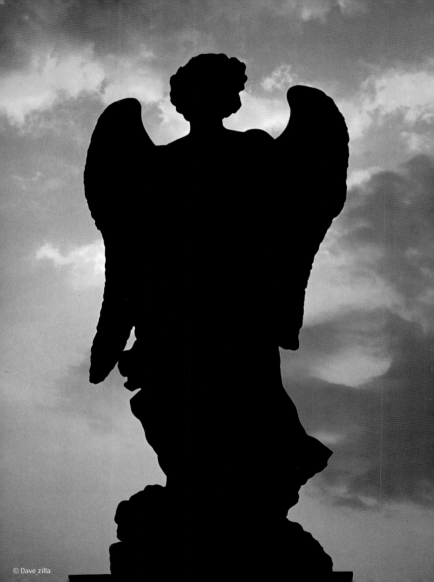

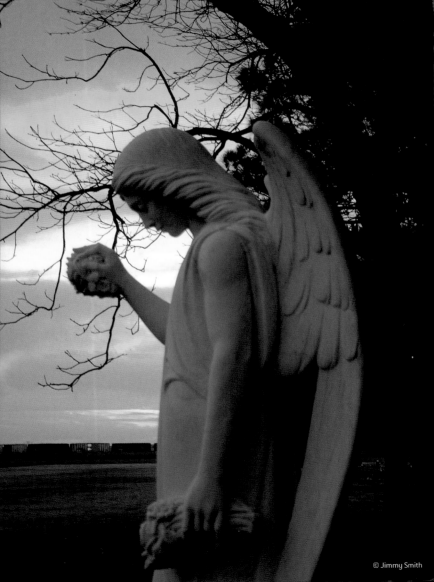

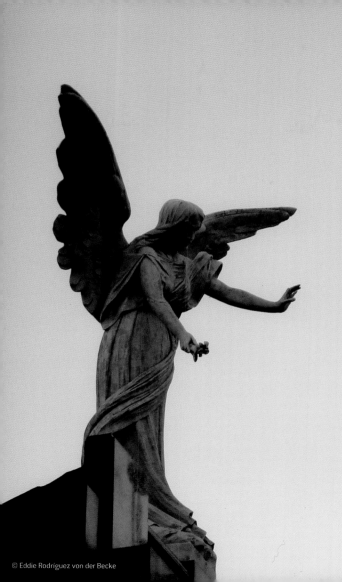

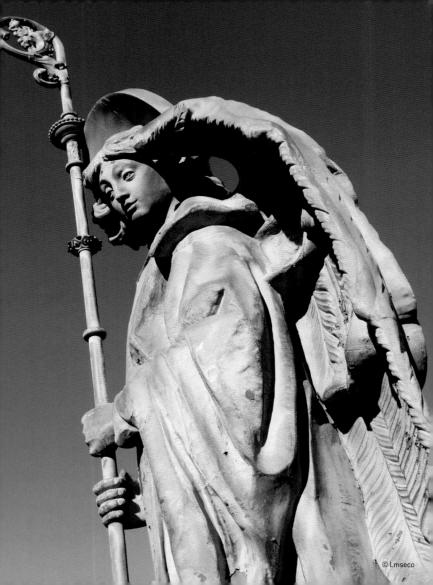

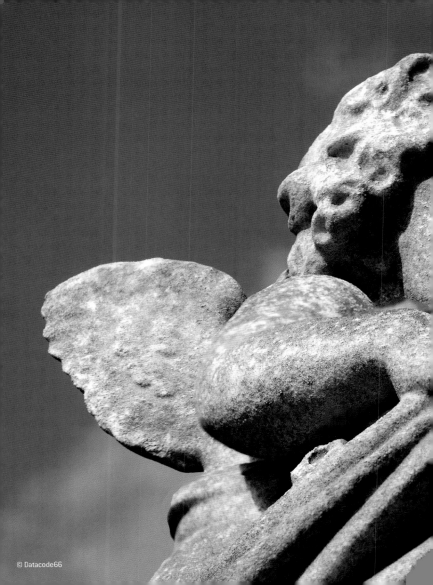

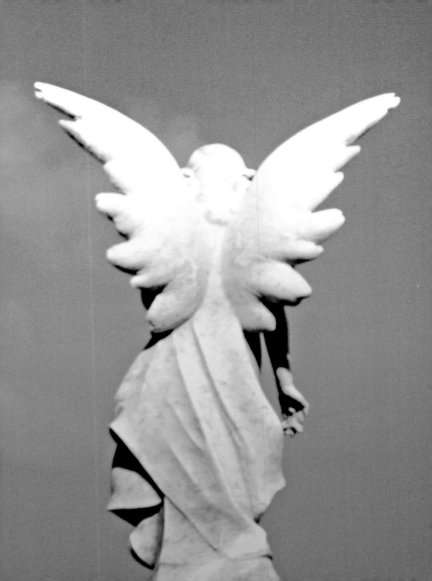

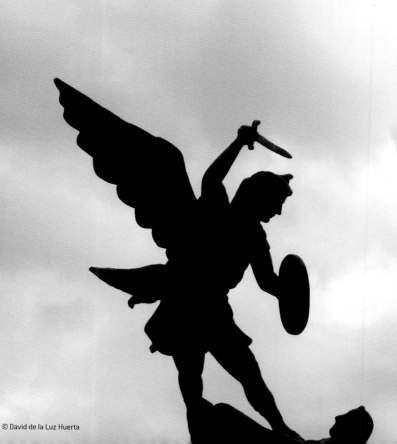

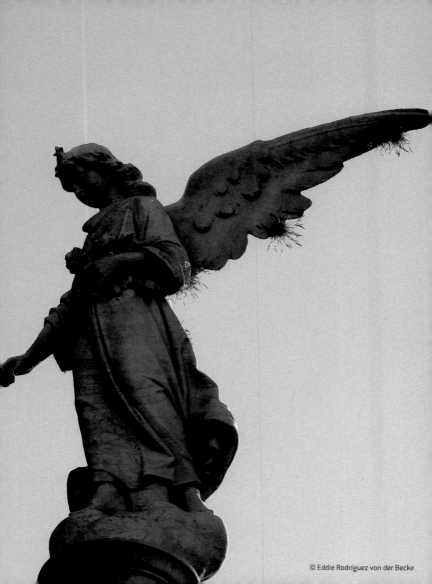

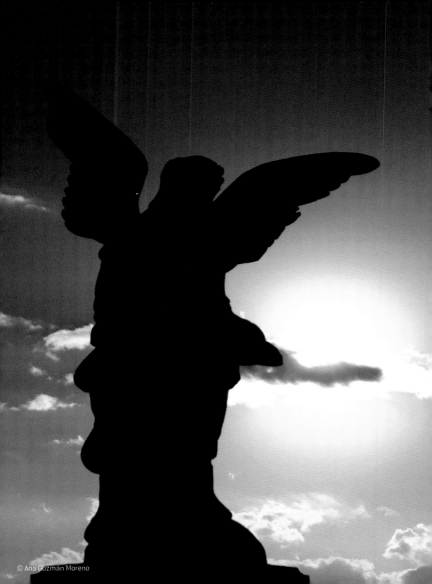

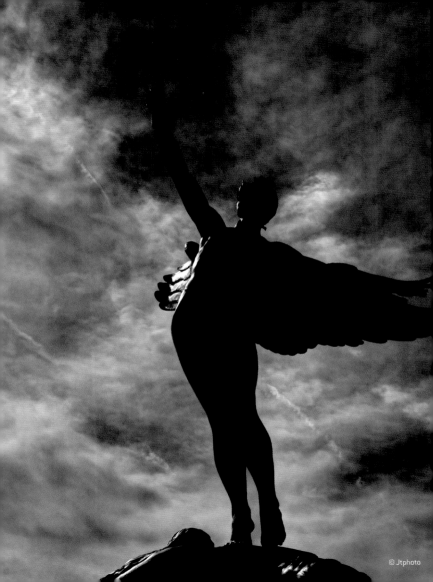

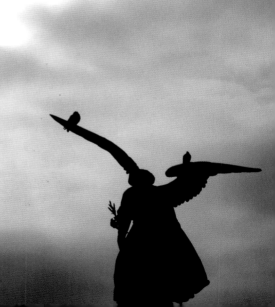

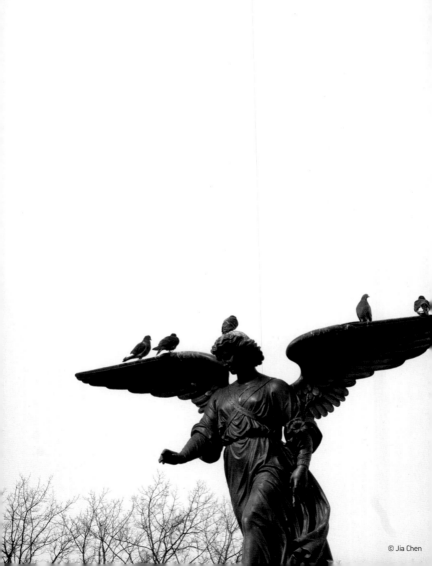

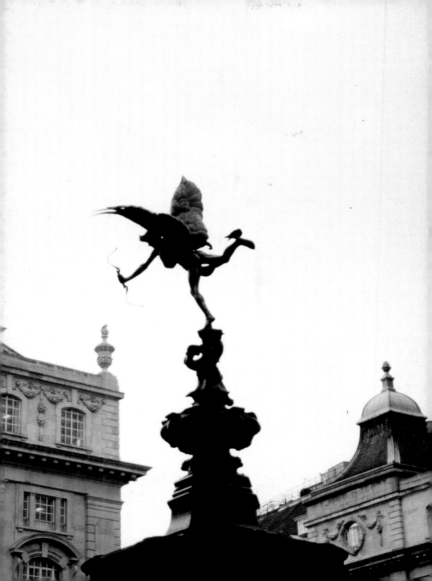

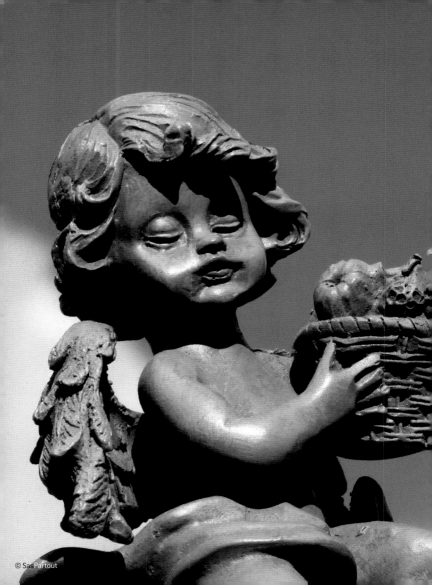

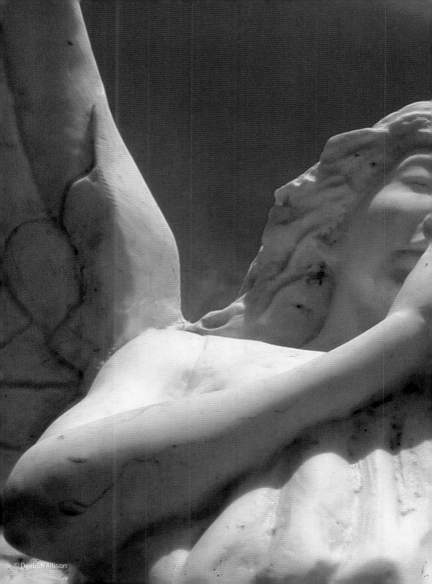

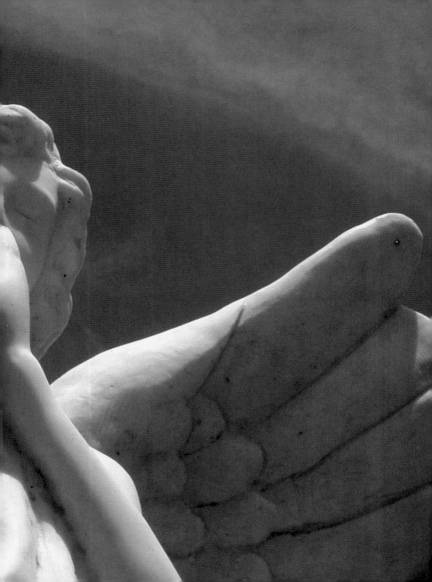

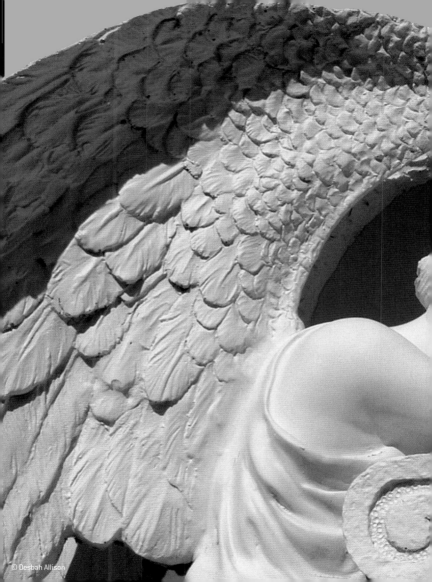

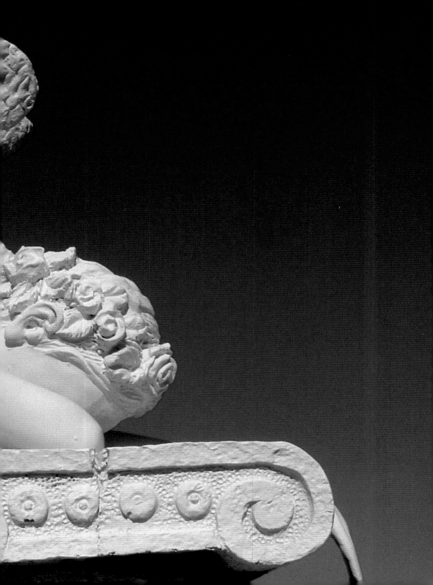

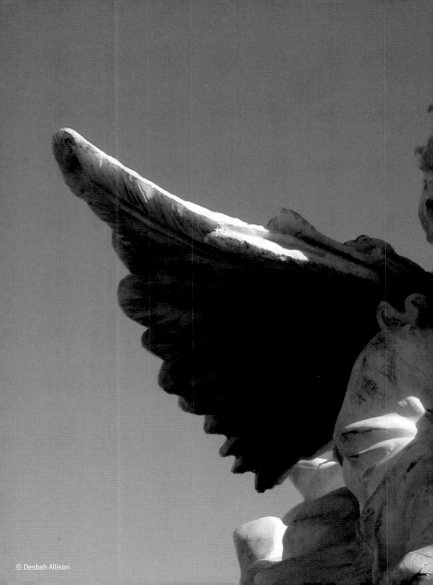

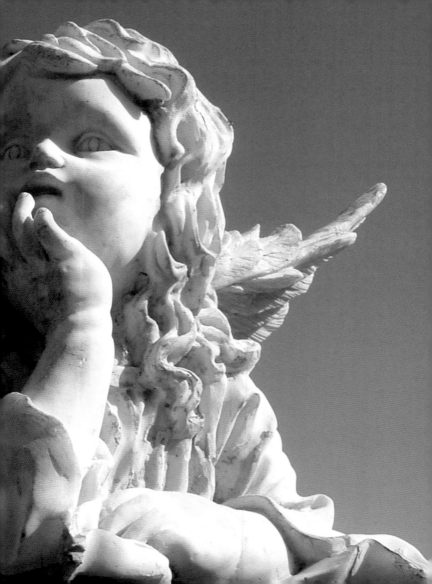

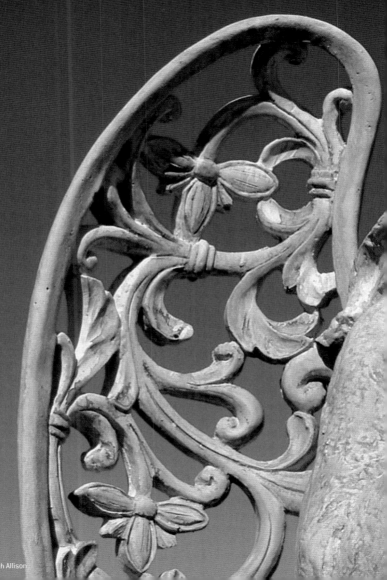

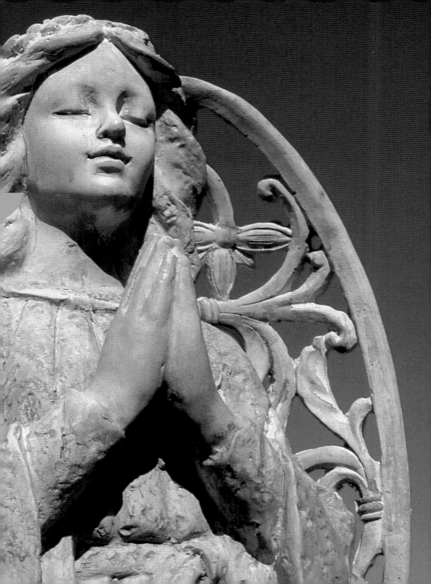

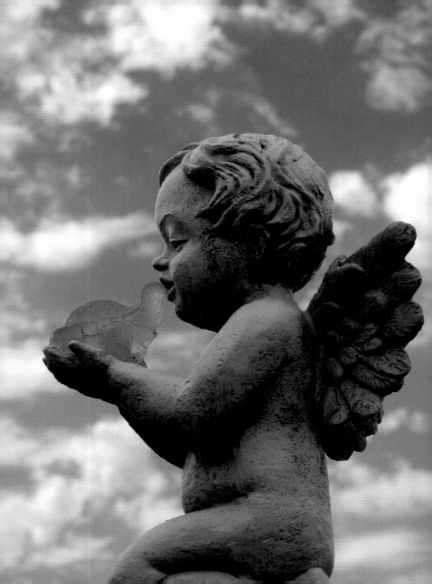

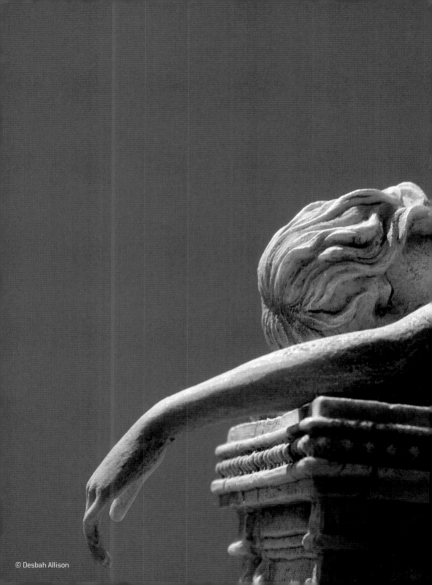

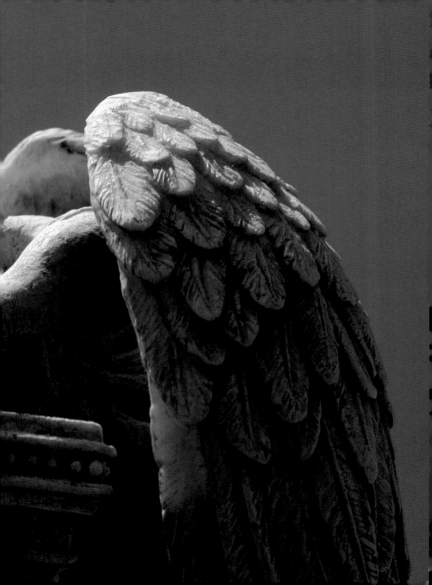

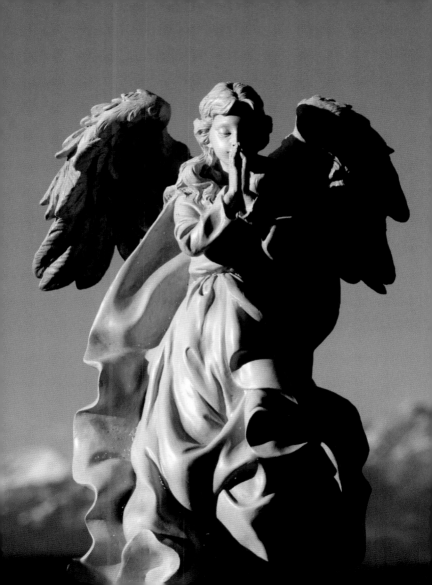

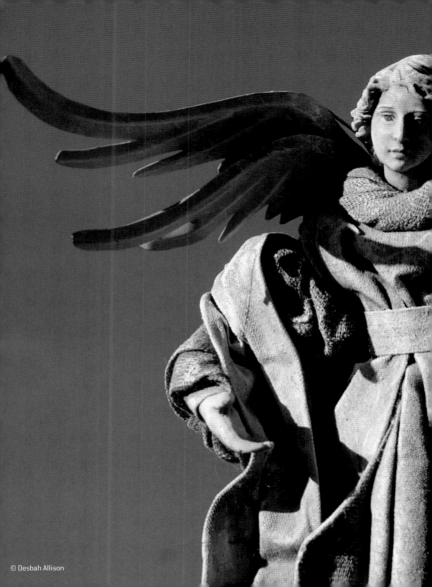

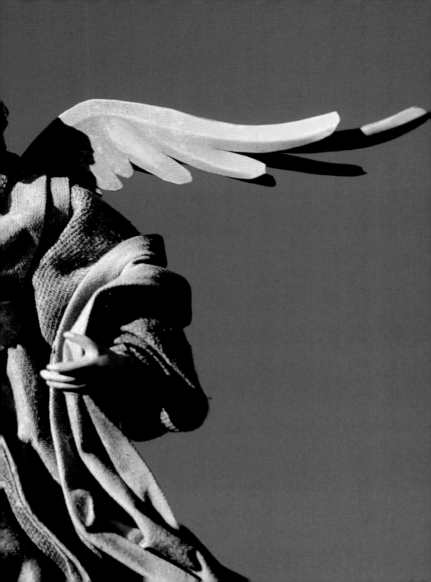

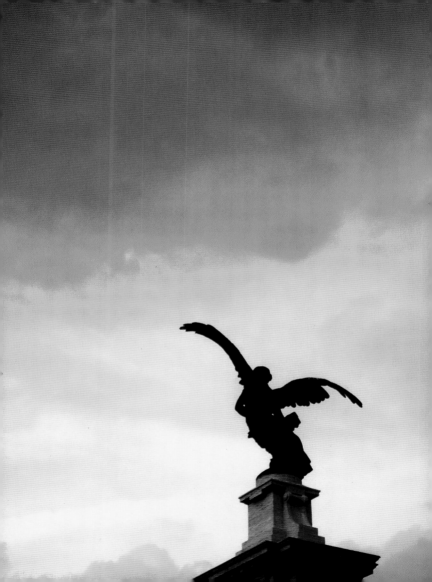

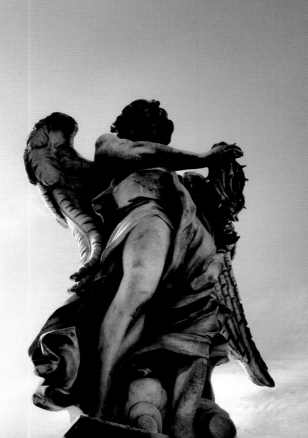

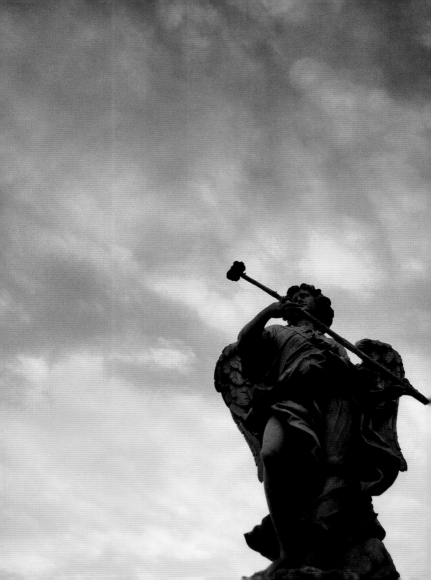

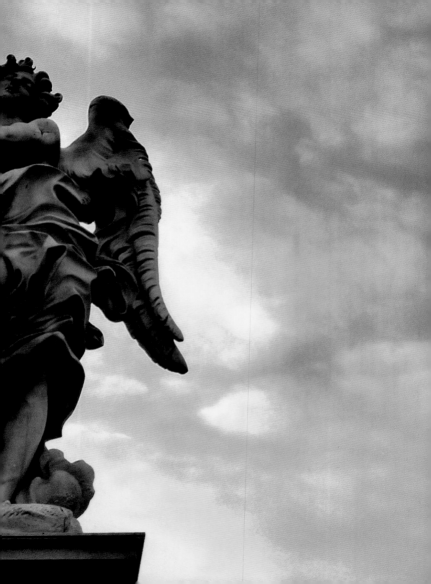

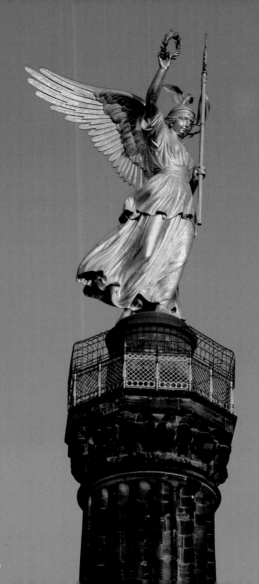

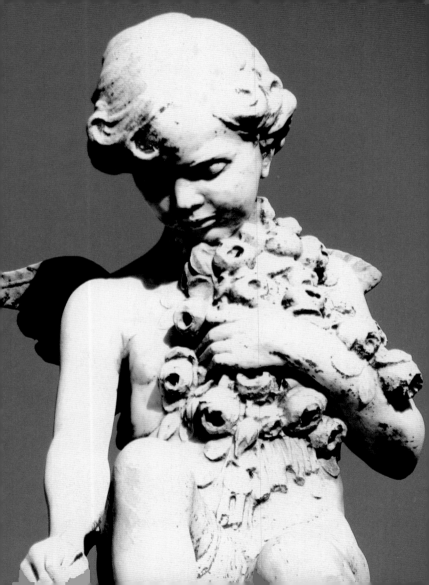

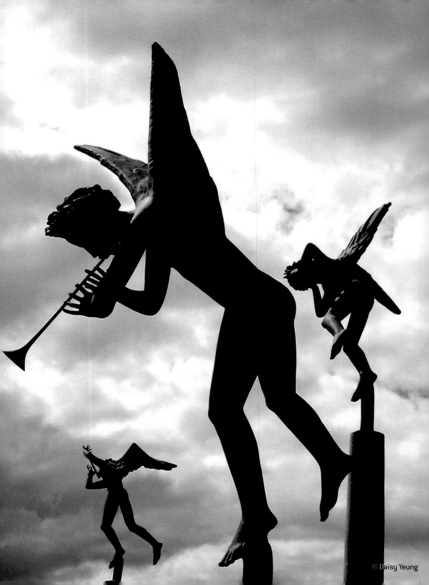

© Daisy Yeung

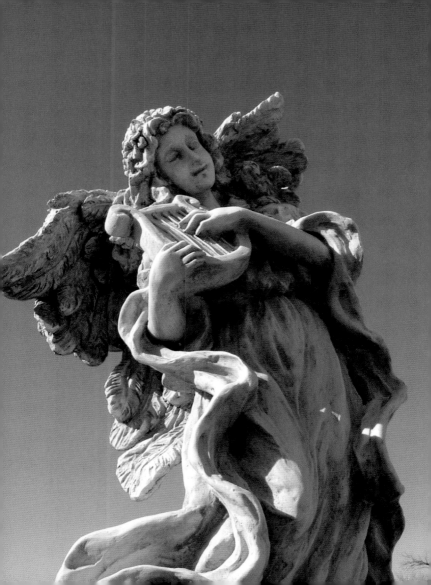

Halfway to heaven

À mi-chemin vers le ciel

Auf halbem Weg ins Himmelreich

Halverwege de hemel

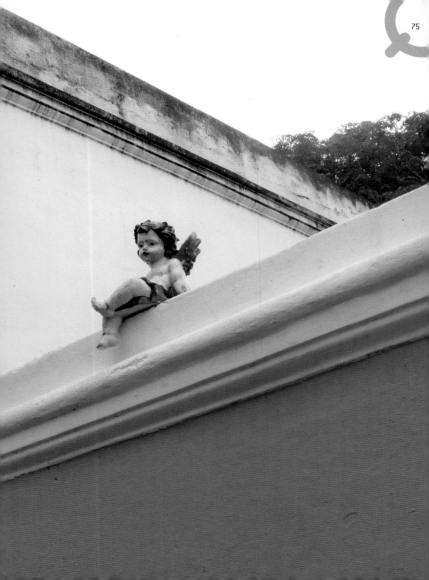

"Angels are spirits, but it is not because they are spirits
that they are angels. They become angels when they
are sent. For the name angel refers to their office, not
their nature. You ask the name of this nature, it is
spirit; you ask its office, it is that of an Angel, which is
a messenger."

St. Augustine

„Engel sind Geister, doch nicht weil sie Geister sind, sind sie auch
Engel. Sie werden zu Engeln, wenn sie geschickt werden. Der Begriff
Engel bezieht sich auf ihre Funktion, nicht auf ihr Wesen. Willst du
die Bezeichnung dieses Wesens wissen sie lautet Geist; fragst du
nach seiner Funktion, so hat es die Funktion eines Engels – eines
Gesandten."

Hl. Augustinus

« Les anges sont des esprits, mais ce n'est pas parce qu'ils sont des esprits qu'ils sont des anges. Ils deviennent des anges quand ils sont envoyés en mission. En effet, le nom d'ange fait référence à leur fonction et non à leur nature. Si vous voulez savoir le nom de leur nature, ce sont des esprits ; si vous voulez savoir le nom de leur fonction, ce sont des anges, ce qui signifie messager. »

Saint Augustin

"Engelen zijn geesten, maar niet omdat zij geesten zijn, zijn het engelen. Ze worden engelen wanneer ze worden gezonden. Het woord engel verwijst naar hun functie, niet naar hun aard. Als je vraagt wat de naam van deze aard is, is het geest; als je vraagt naar hun functie, dan is dat die van engel: een boodschapper."

De heilige Augustinus

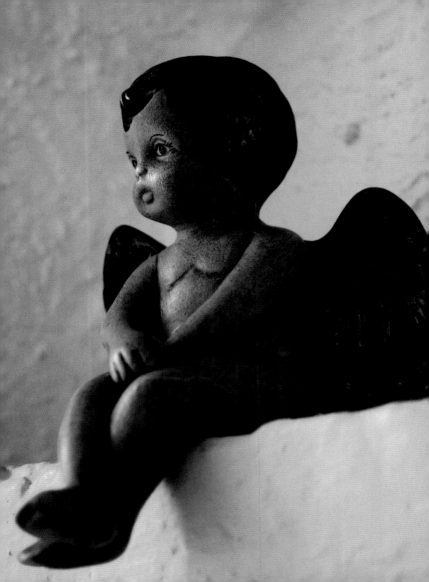

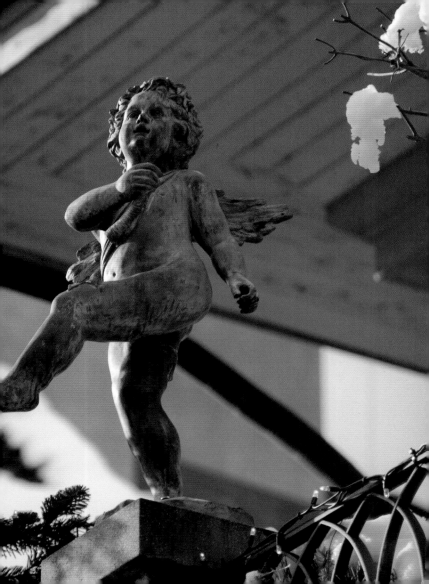

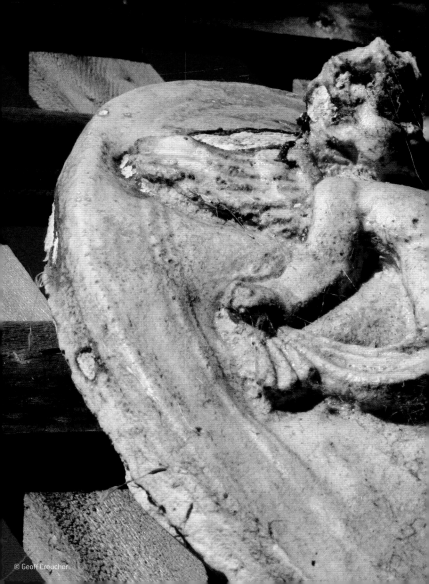

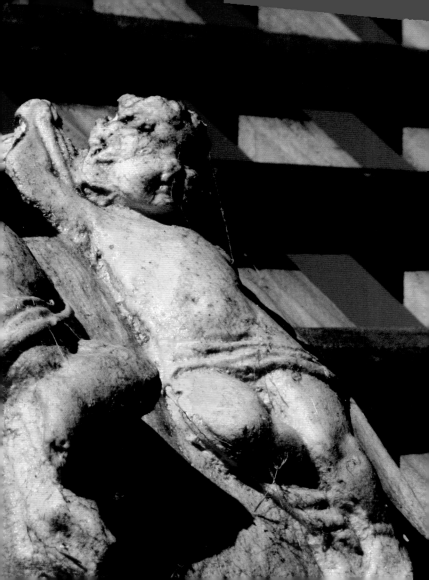

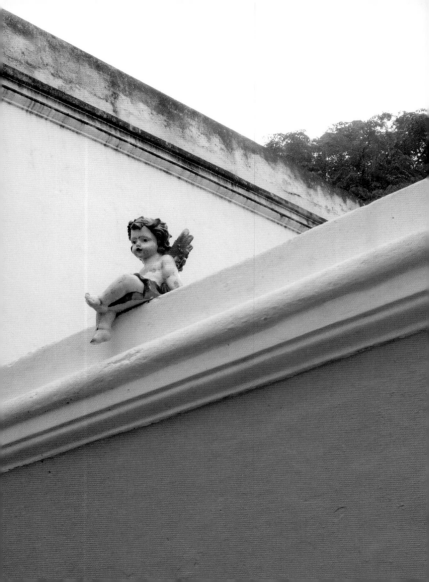

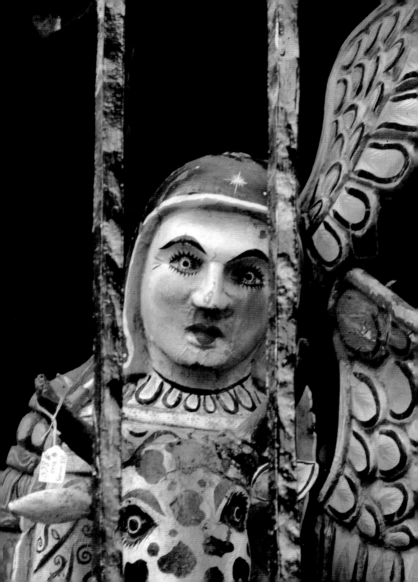

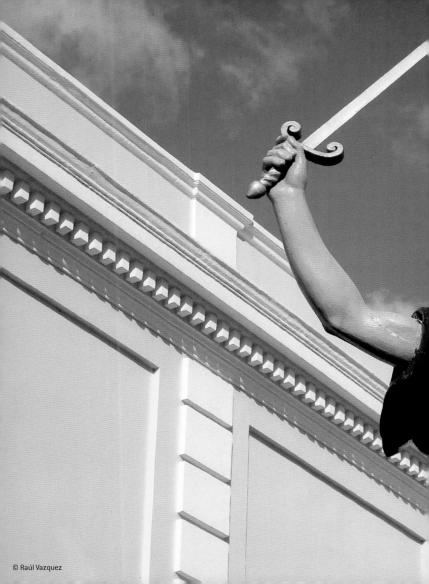

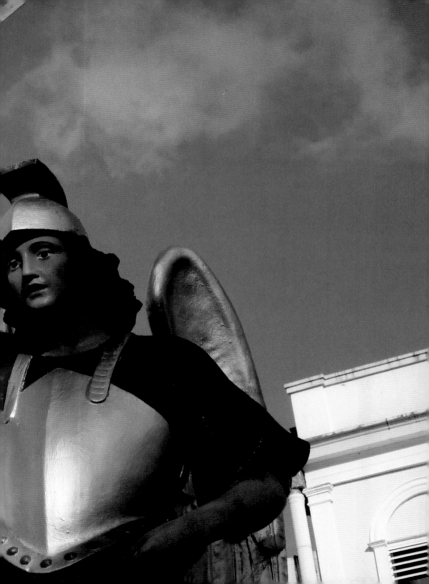

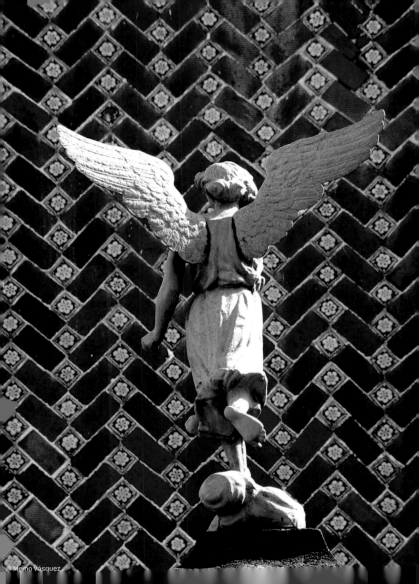

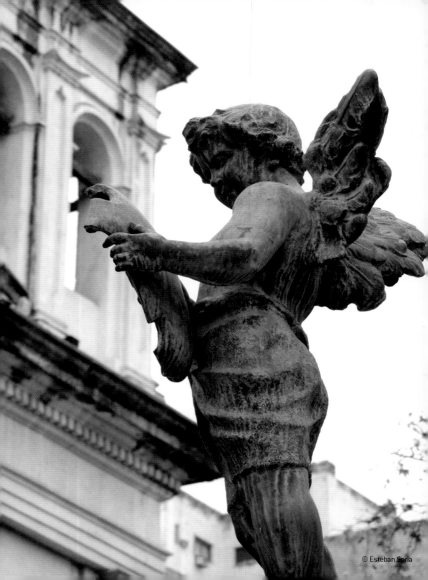

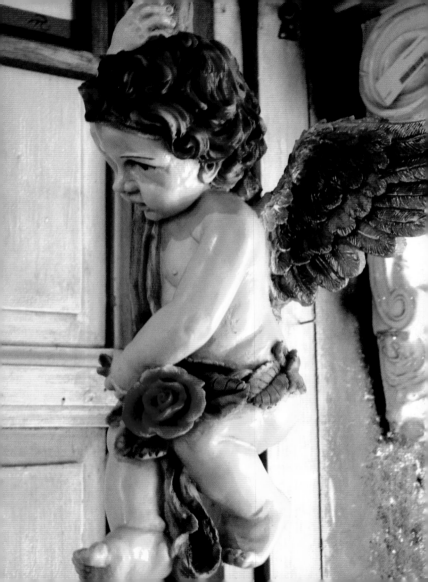

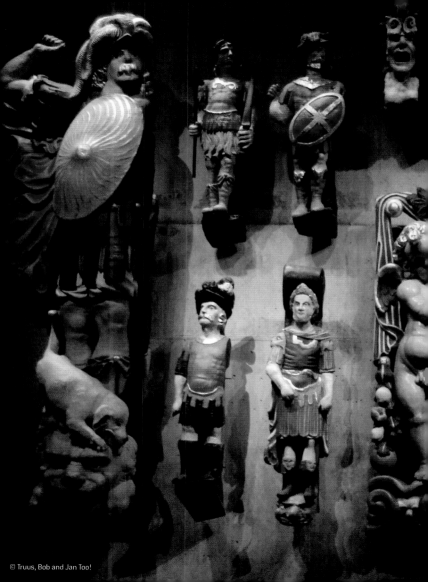

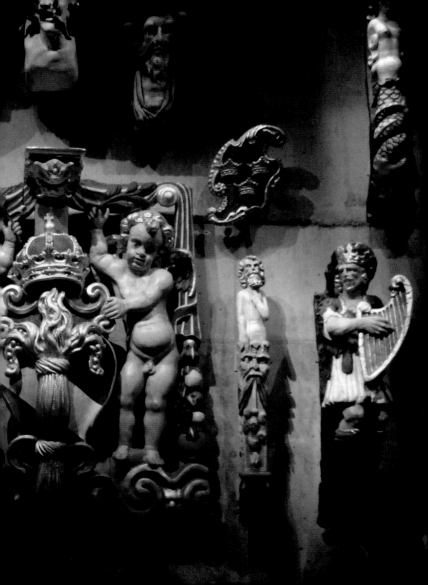

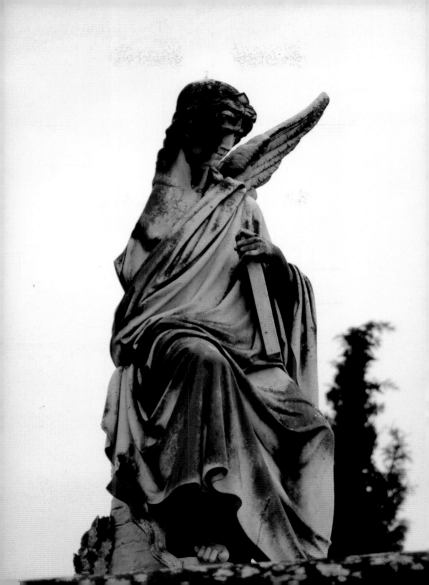

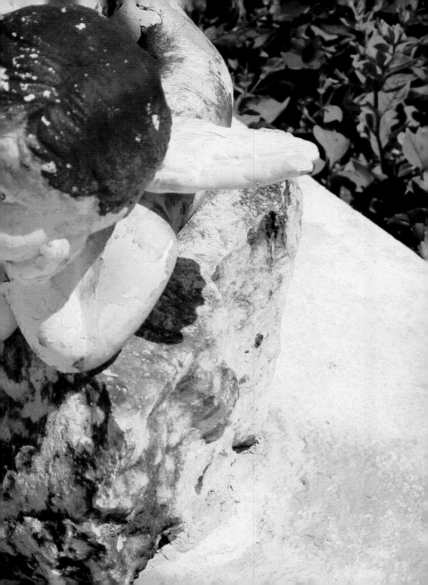

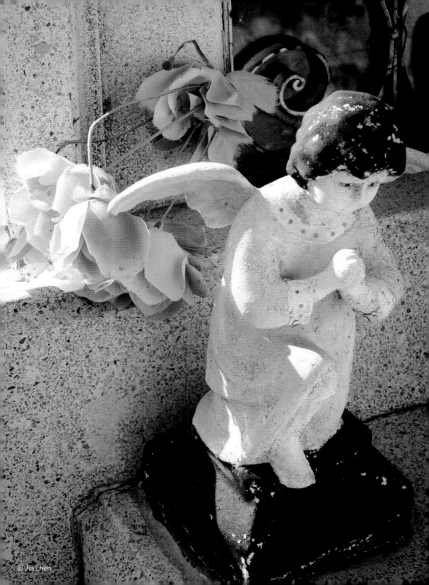
© Jia Chen

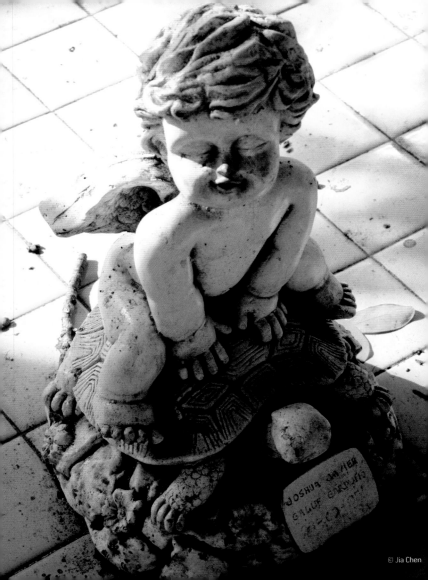

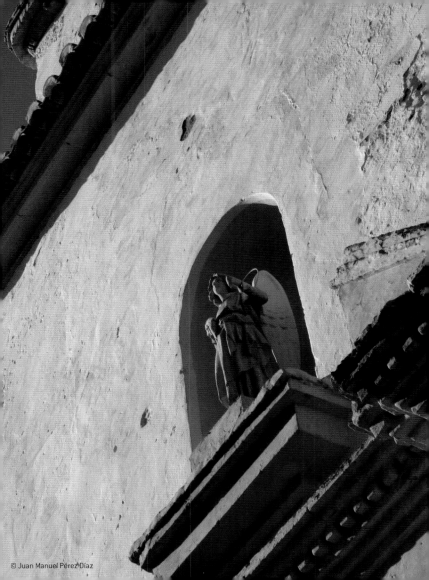

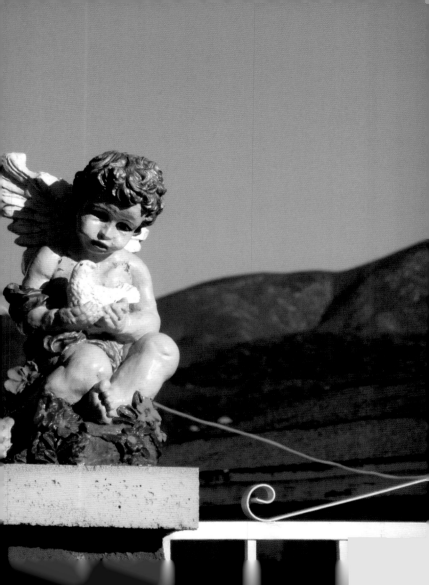

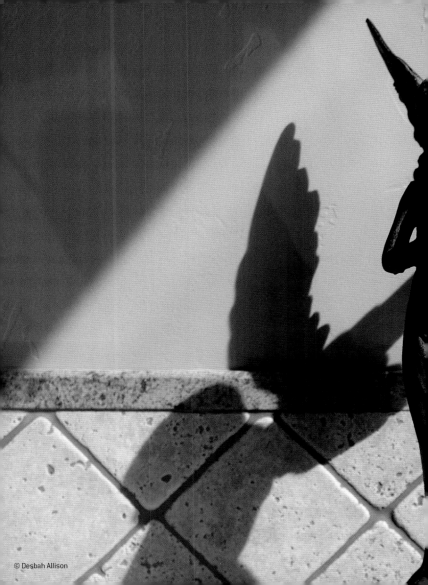

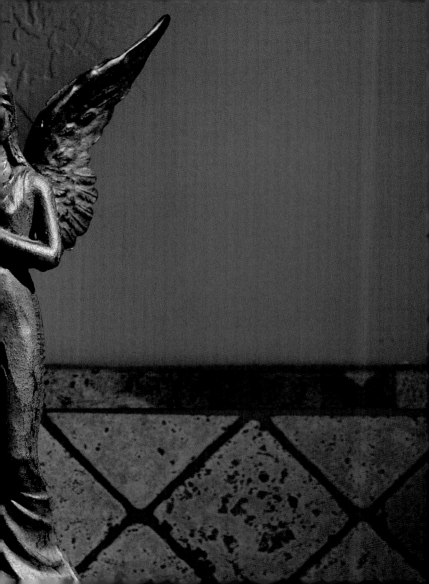

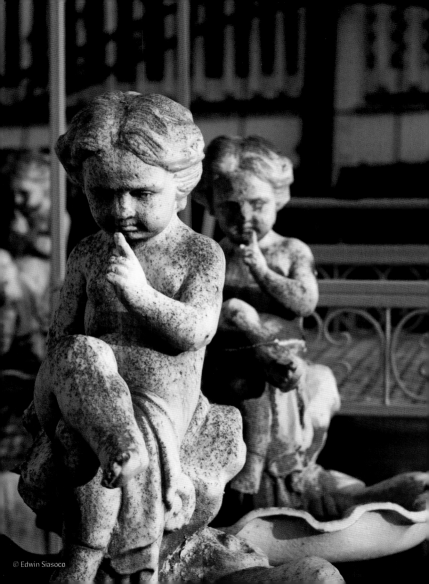

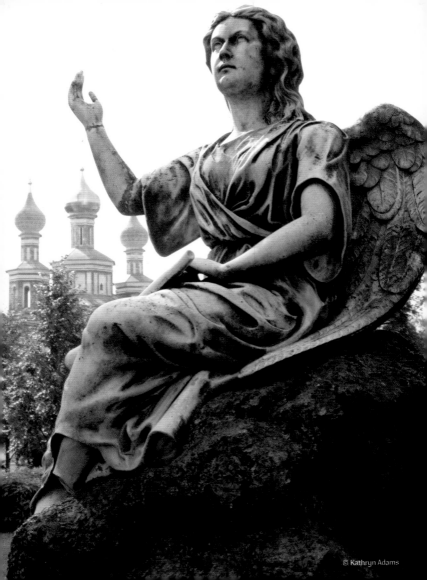
© Kathryn Adams

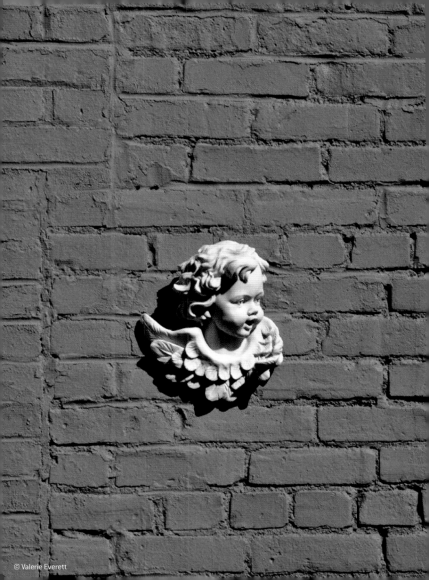

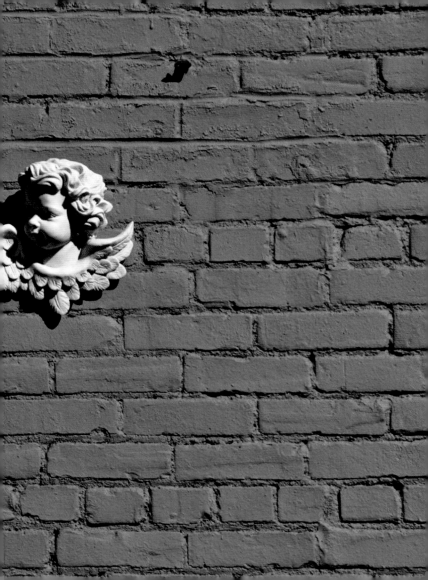

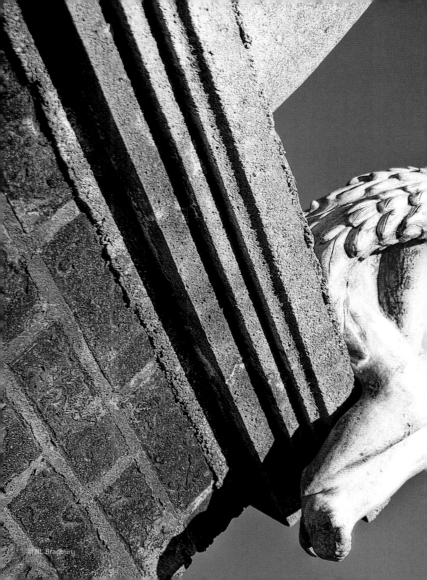

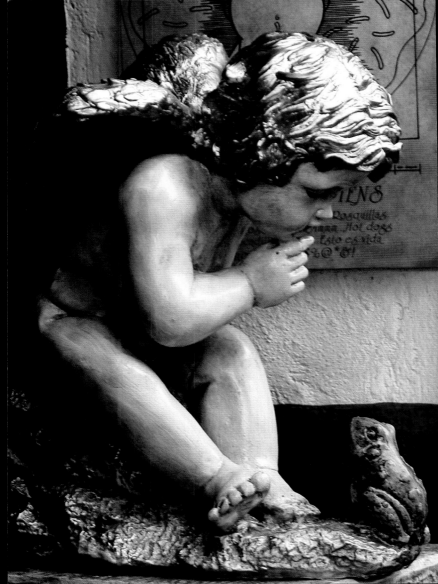

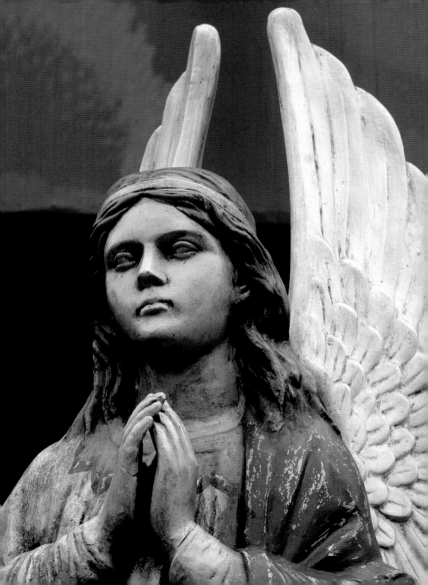

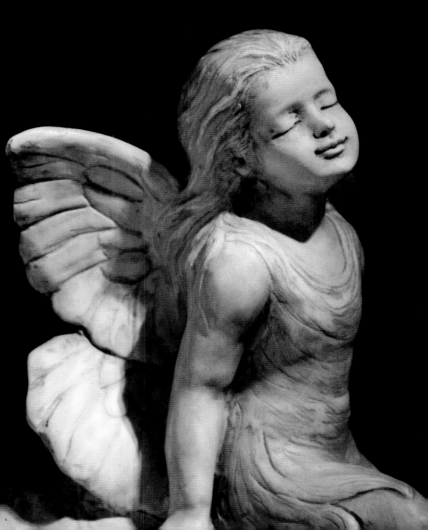

© Alberto Rojas Serrano

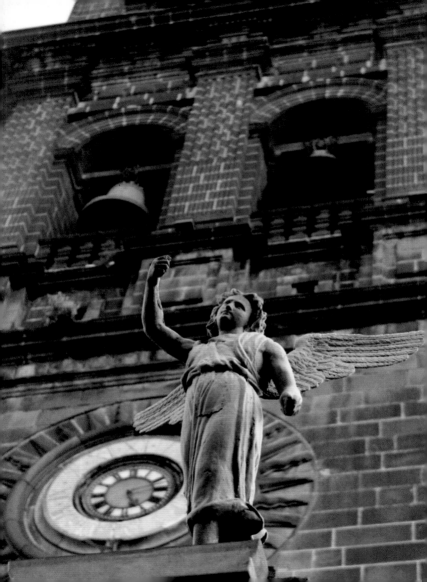

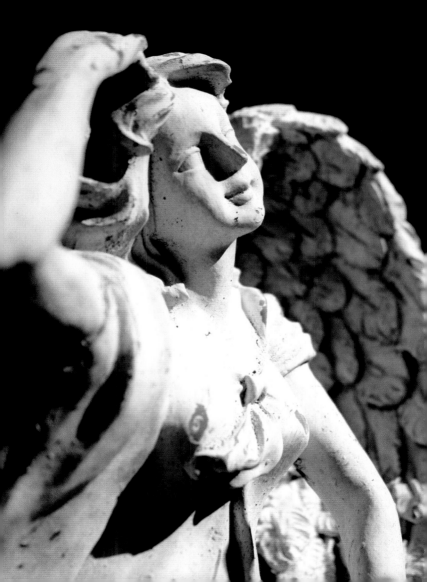

Always watching

Toujours regarder

Immer wachend

Immer wakend

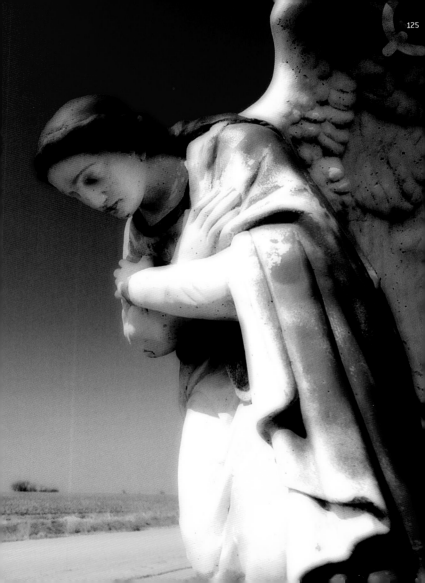

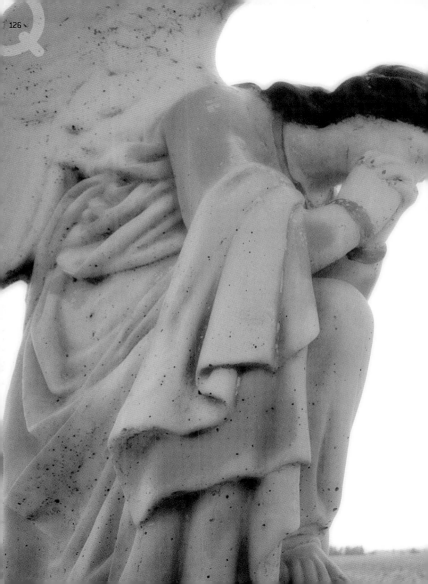

"And the Angel said, 'I have learned that every man lives,
not through care of himself, but by love'."

Leo Tolstoy

« Et l'ange dit : J'ai appris que tout homme vit non pas
grâce au soin qu'il se porte, mais grâce à l'amour. »

Léon Tolstoï

„Und der Engel sagte: Ich habe erfahren, dass der Mensch
nicht dadurch lebt, indem er für sich selbst sorgt, sondern
durch die Liebe..."

Leo Tolstoi

"En de engel zei: 'Ik heb geleerd dat de mens leeft,
niet door voor zichzelf te zorgen, maar uit liefde'."

Leo Tolstoj

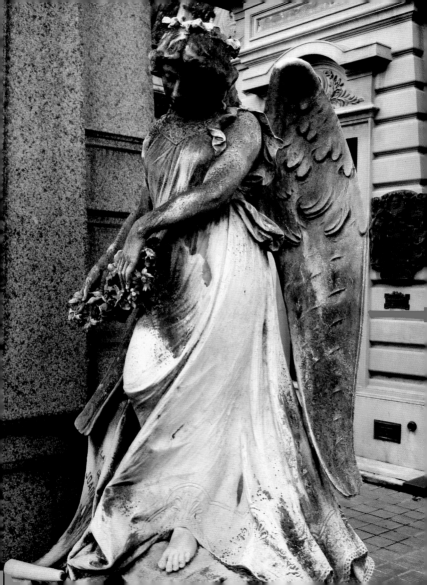

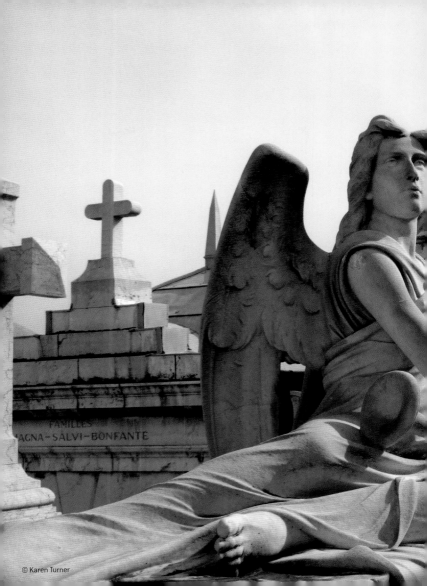

FAMILLES
AGNA - SALVI - BONFANTE

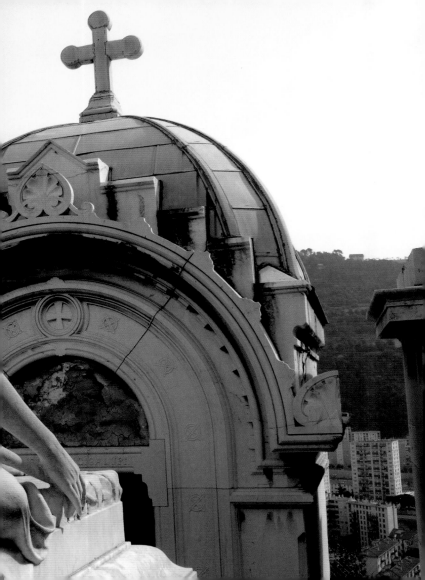

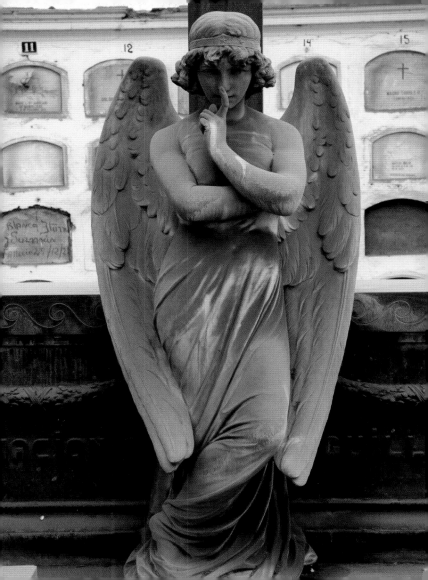

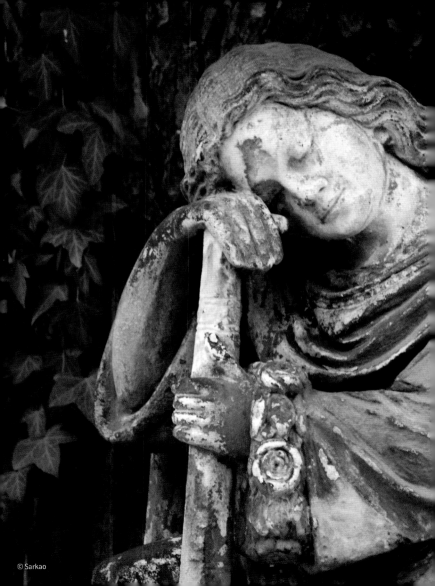

© Sarkao

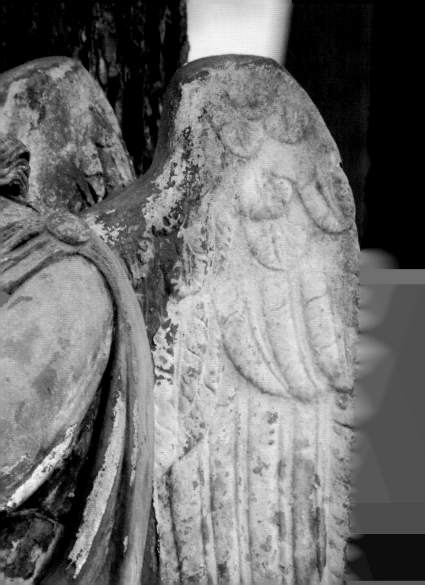

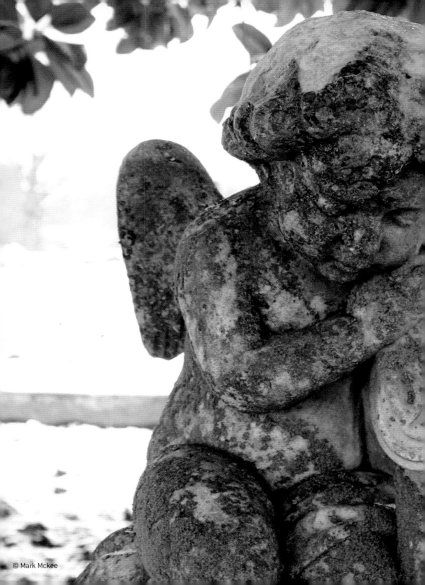

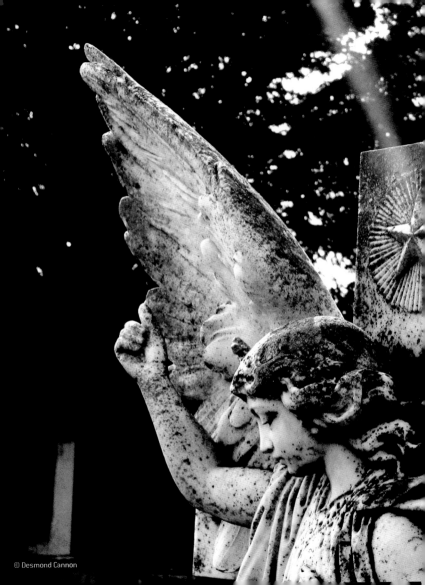
© Desmond Cannon

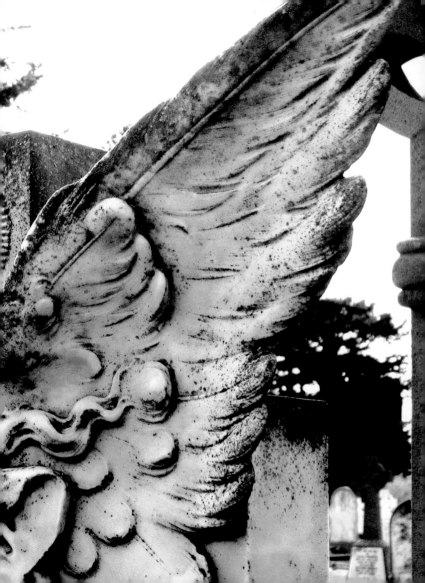

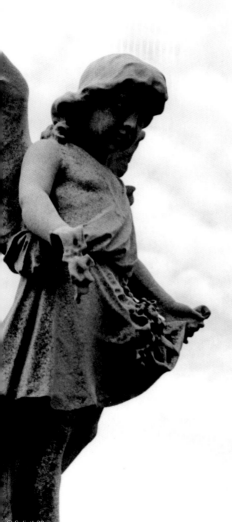

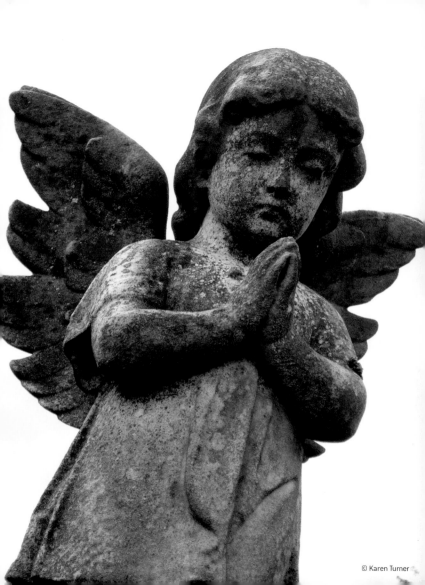

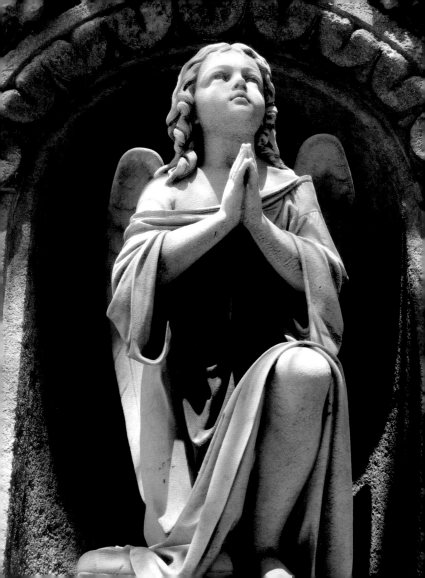

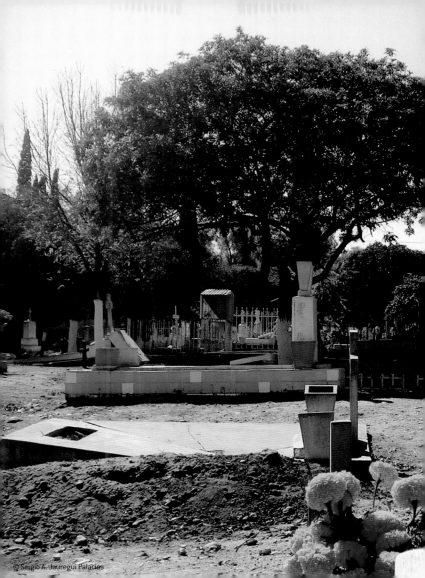

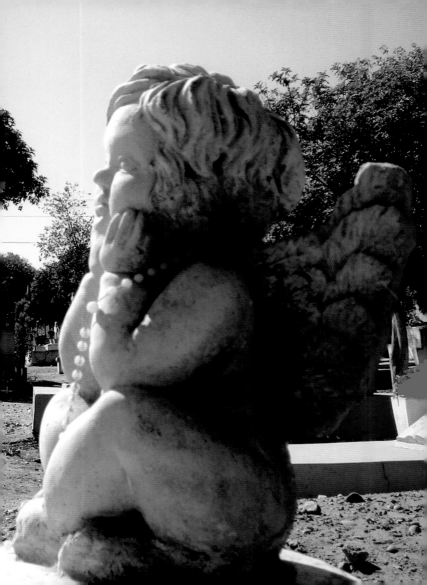

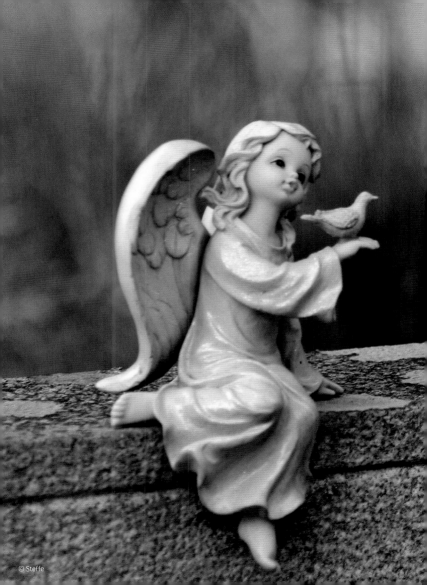

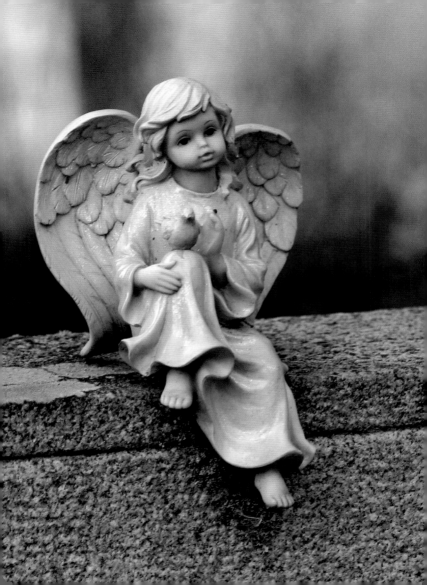

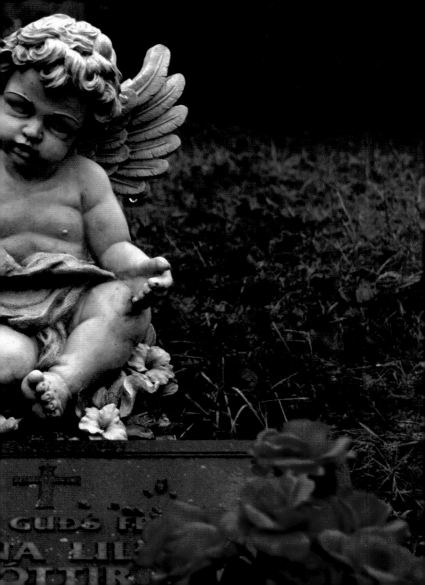

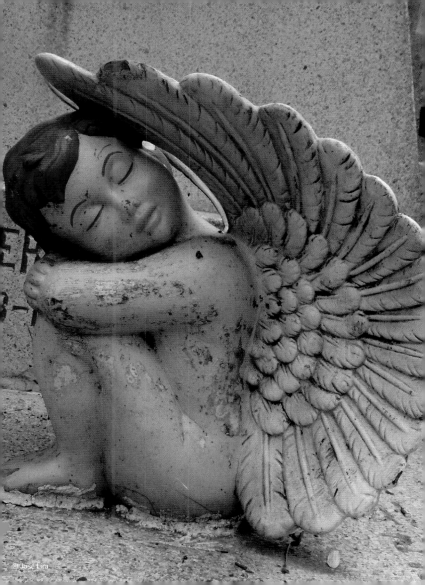
© José Lira

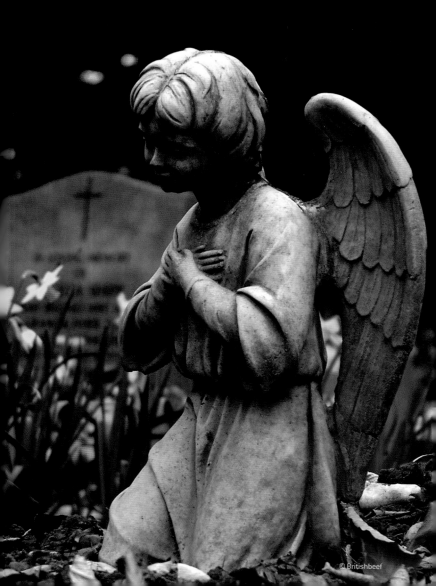

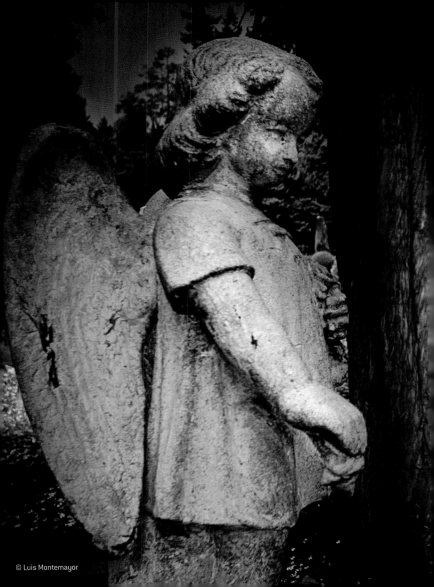

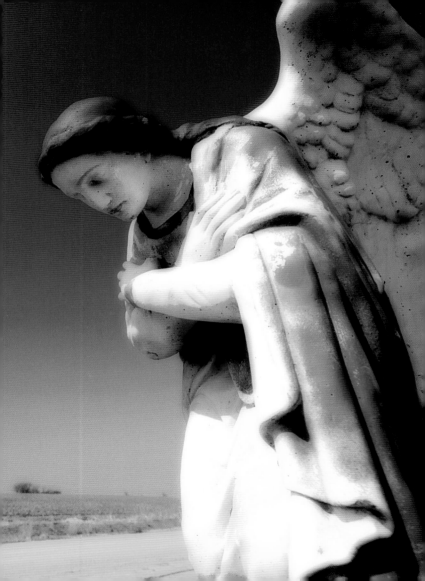

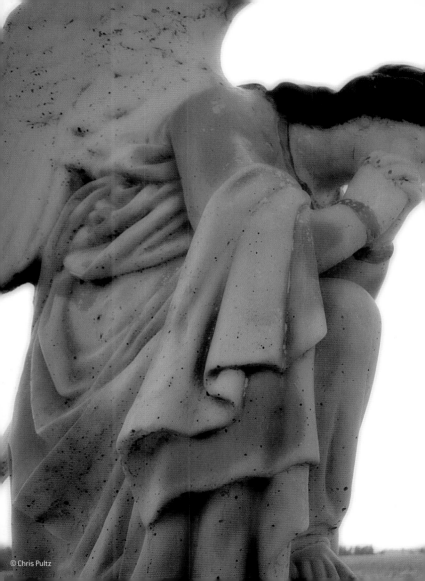

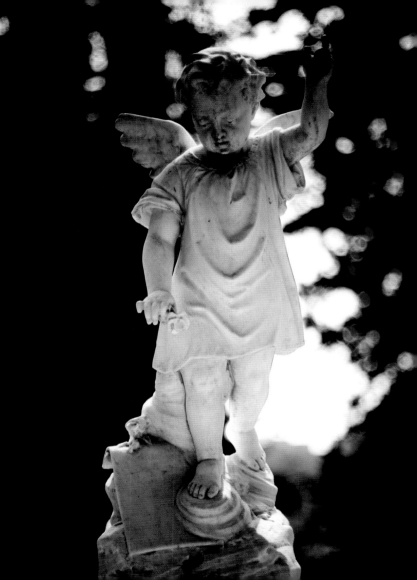

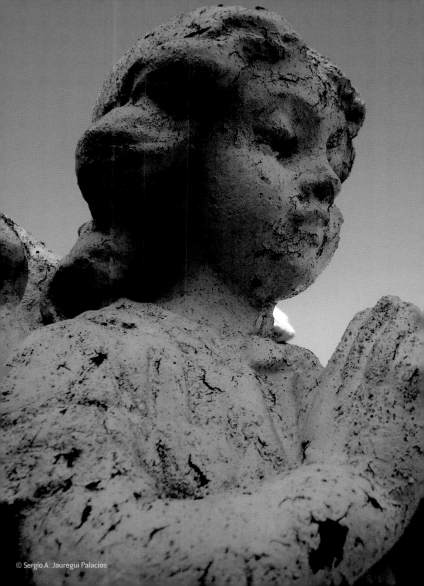

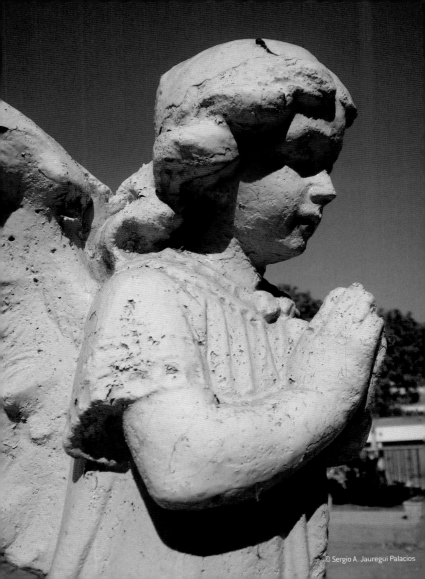

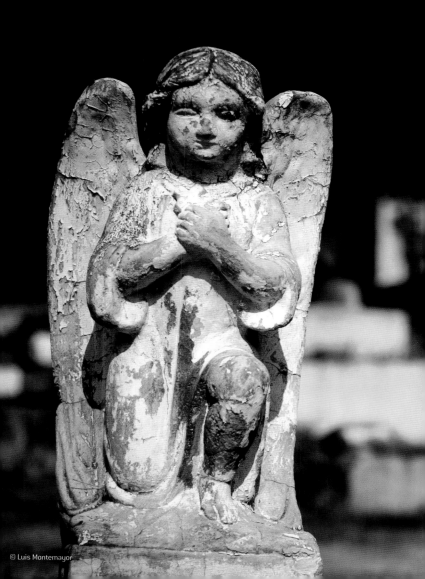

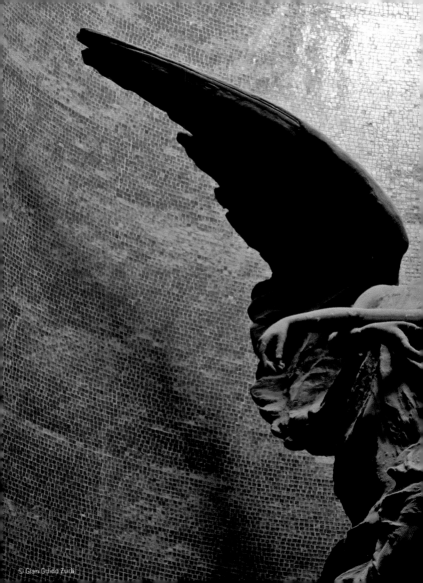

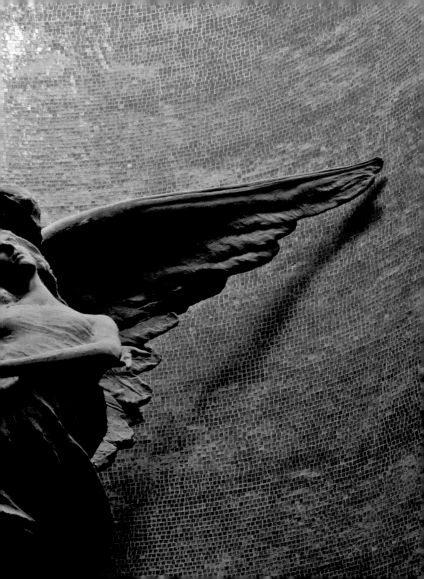

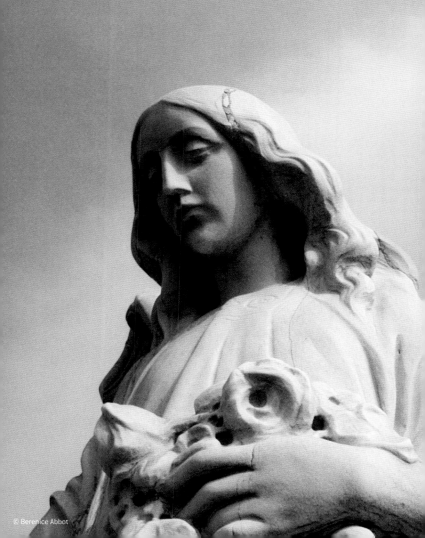

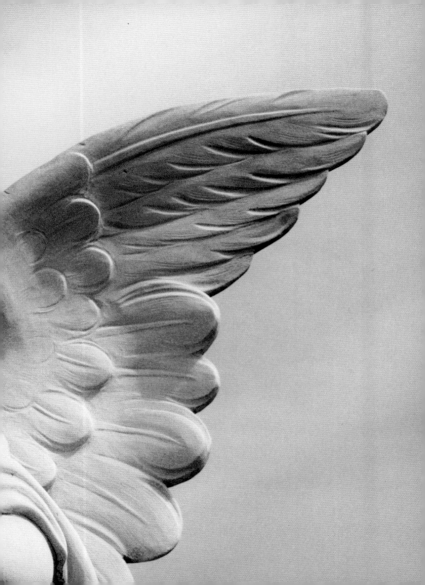

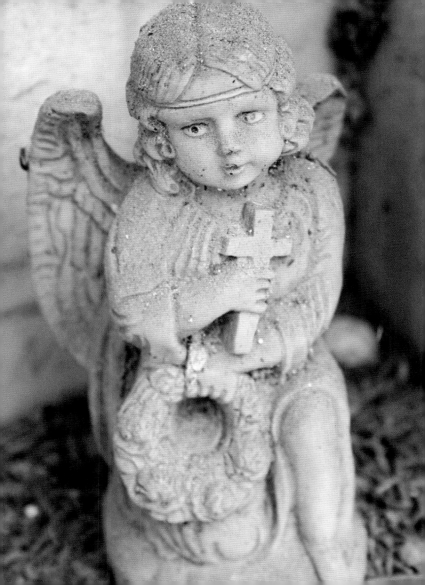

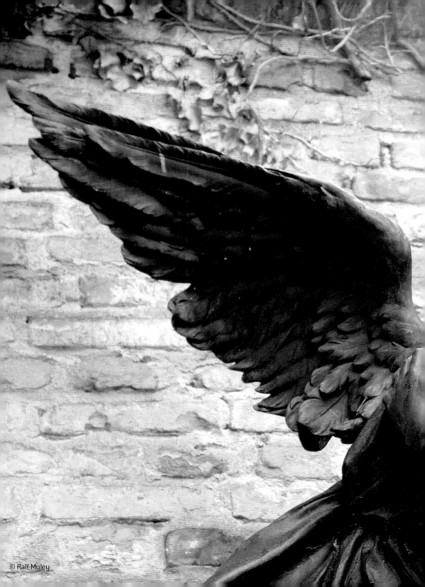
© Ralf Muley

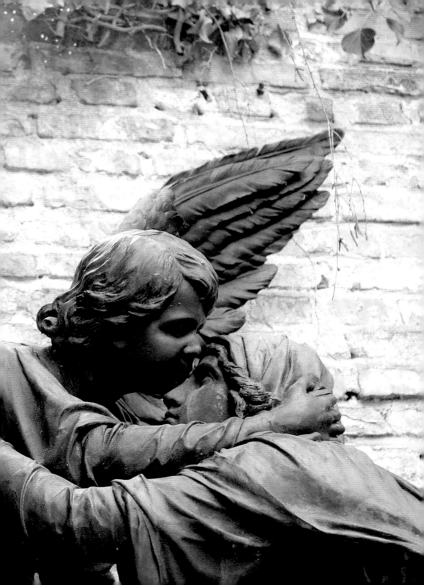

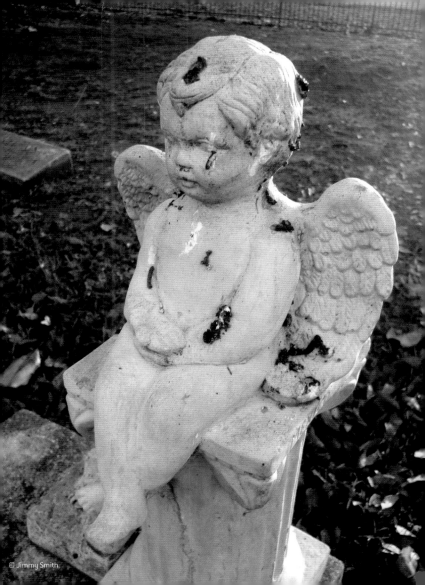
© Jimmy Smith

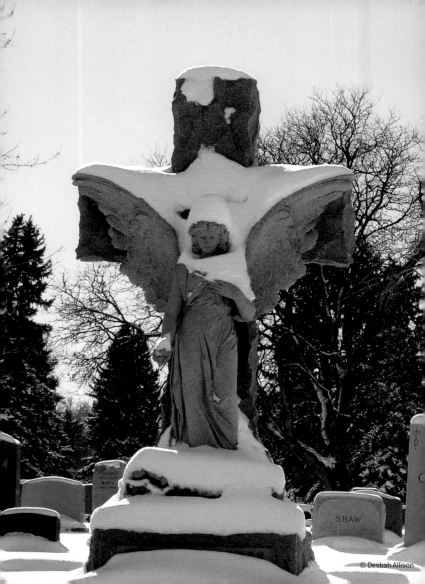

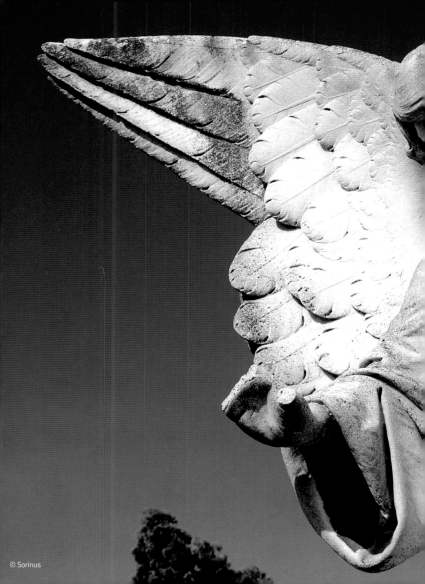

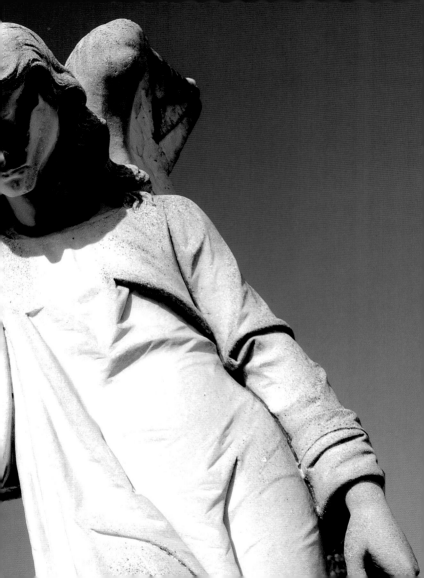

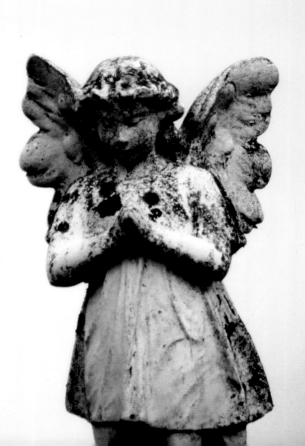

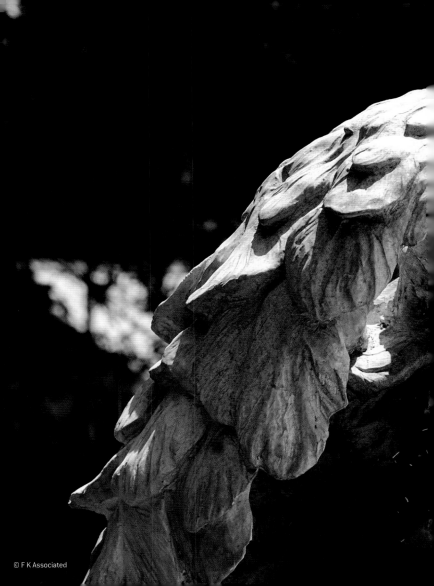

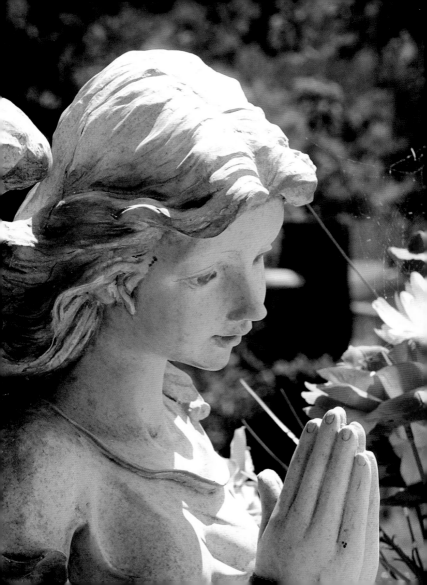

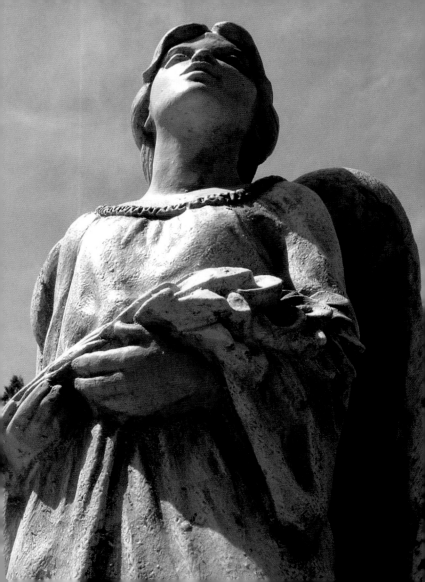

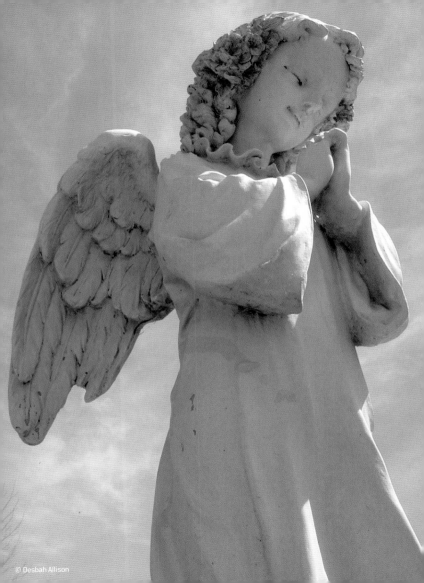

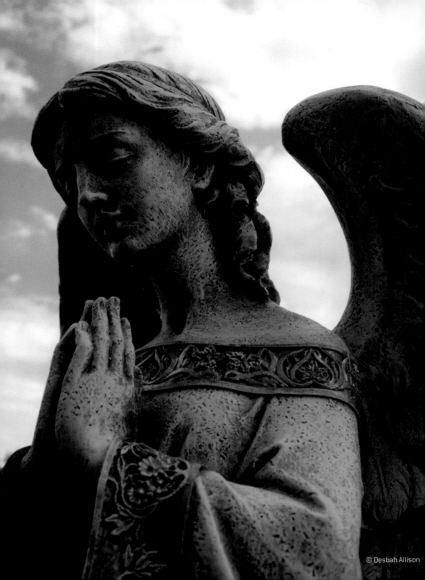

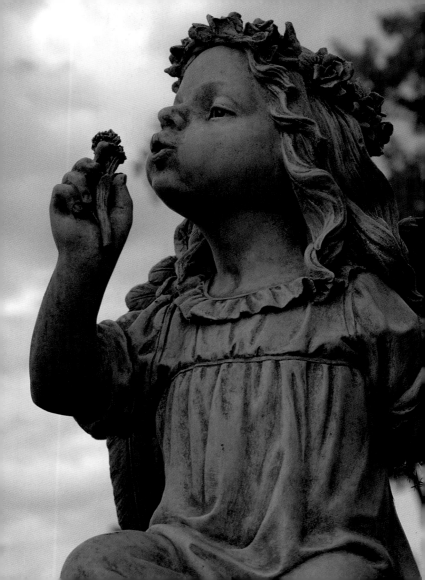

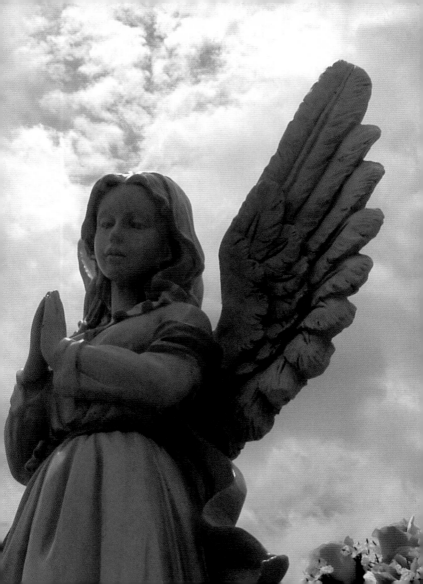

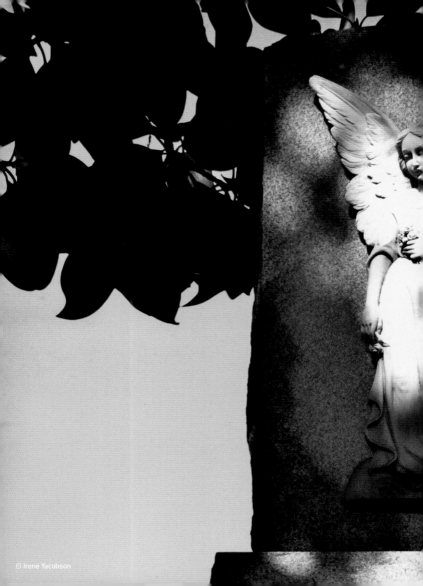

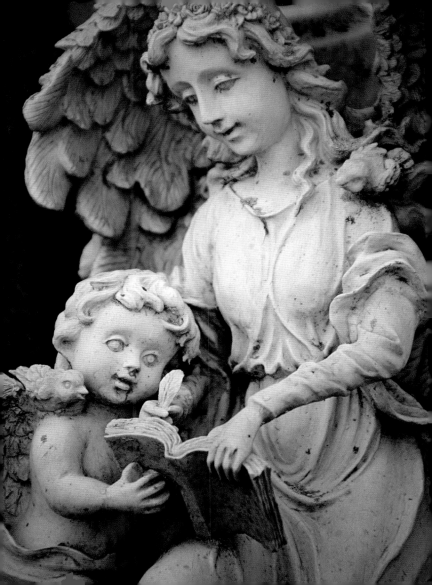

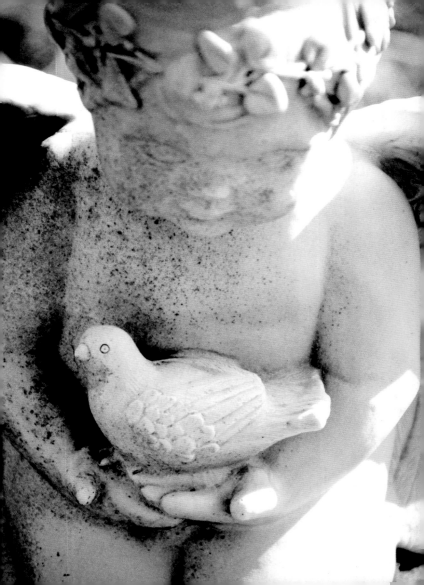

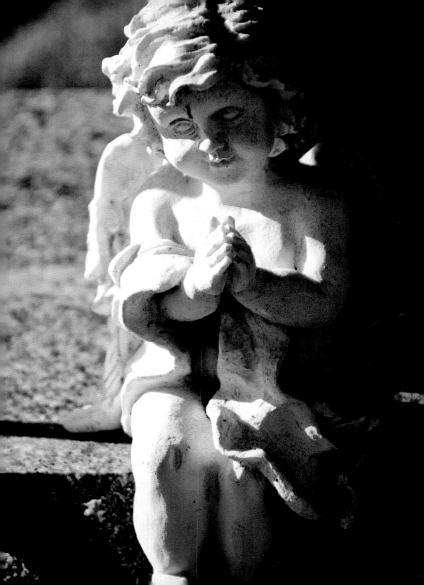

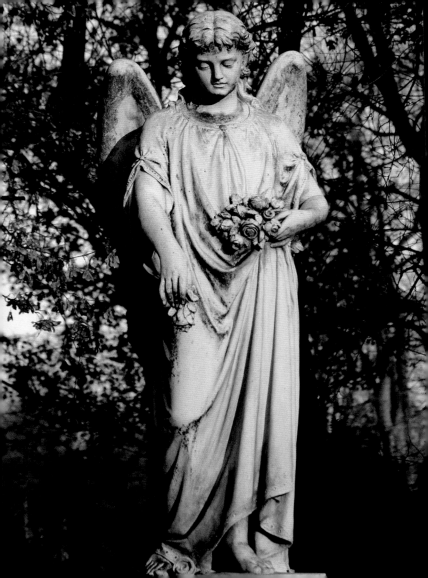

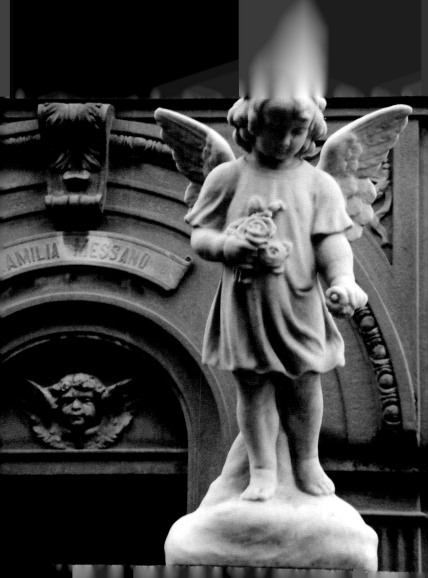

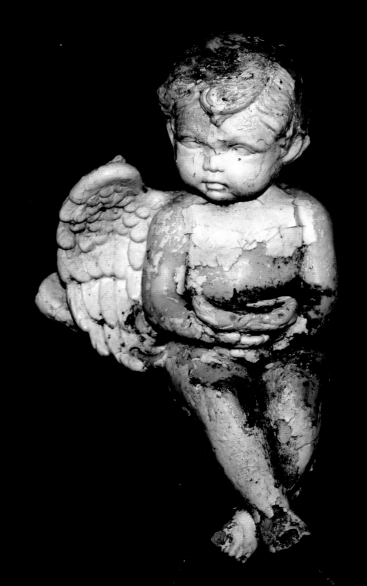

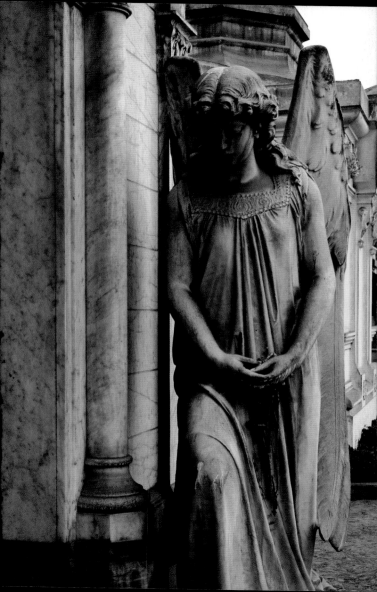

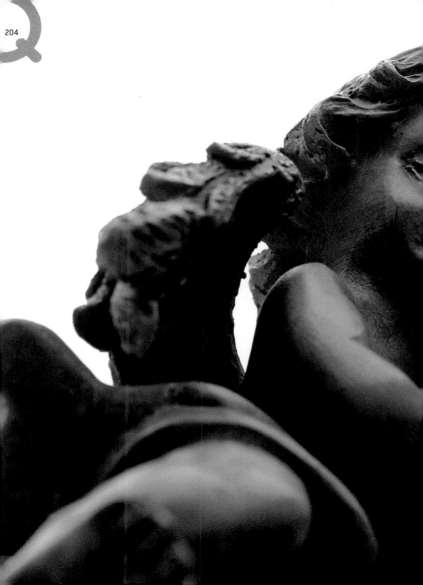

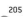

Whisper in my ear

Murmure à mon oreille

Flüstere mir ins Ohr

Fluister in mijn oor

"An angel can illume the thought and mind of man by strengthening the power of vision, and by bringing within his reach some truth which the angel himself contemplates."

St. Thomas Aquinas

„Ein Engel kann das Denken und den Geist eines Menschen erleuchten, indem er dessen Kraft der Vision stärkt und indem er ihm eine Wahrheit bringt, die der Engel selbst betrachtet."

Thomas von Aquin

« Un ange peut illuminer l'intelligence et la pensée d'un homme en renforçant son pouvoir de vision et en mettant à sa portée une vérité à laquelle l'ange lui-même aspire. »

Saint Thomas d'Aquin

"Een engel kan de gedachte en de geest van een mens verlichten door het inzichtsvermogen te versterken en de waarheid, die de engel zelf contempleert, binnen zijn bereik te brengen."

De heilige Thomas van Aquino

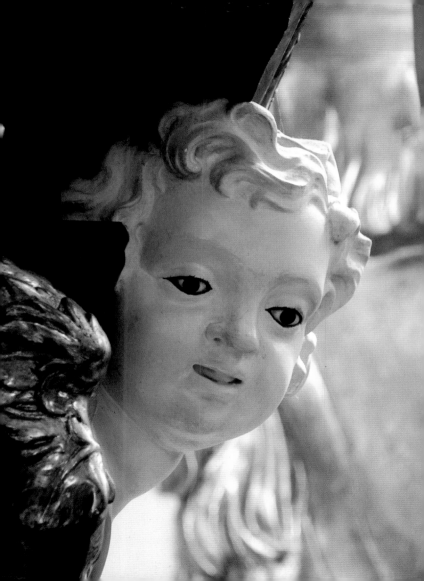

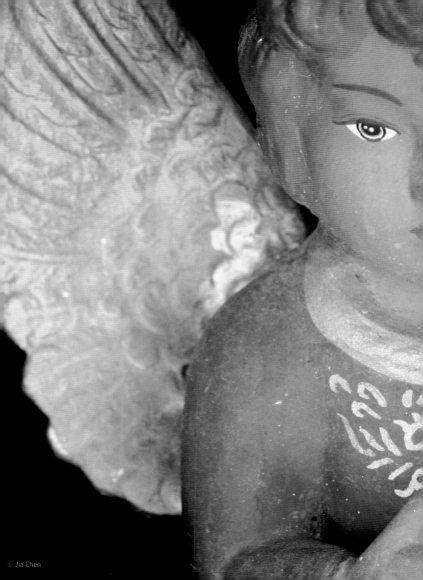

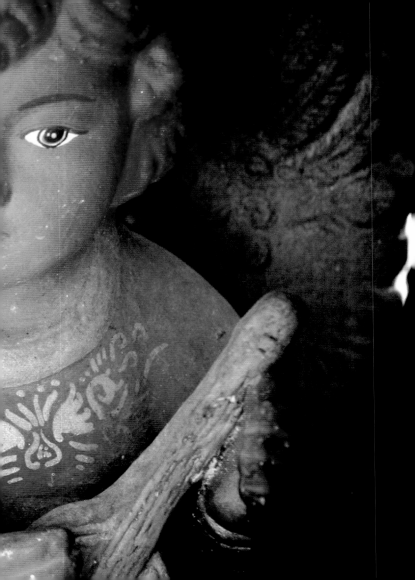

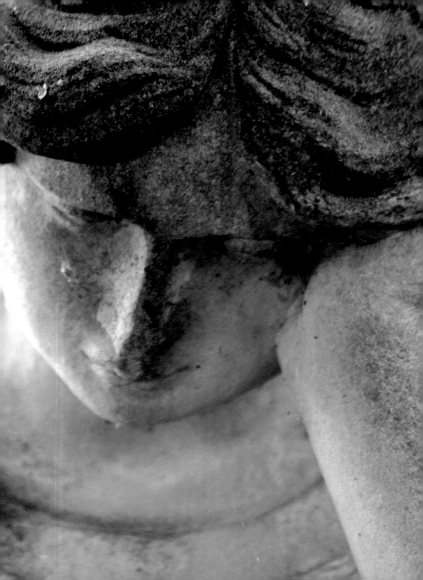

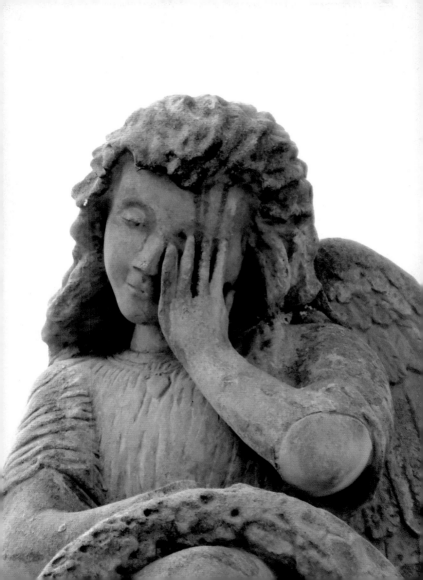

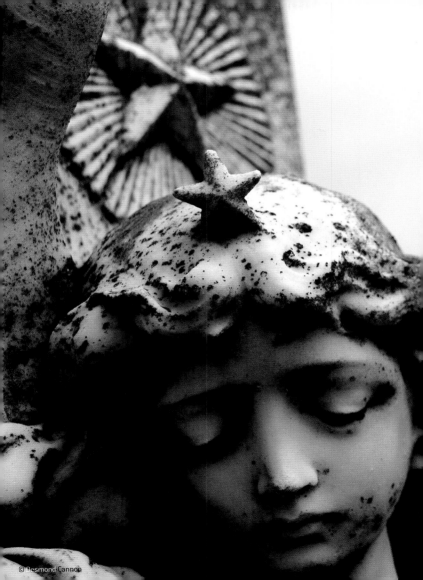

© Desmond Cannon

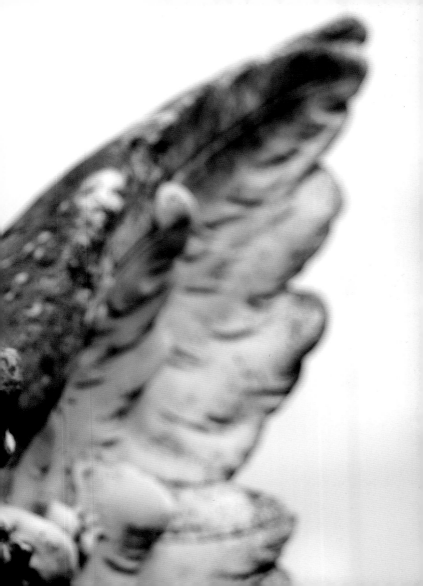

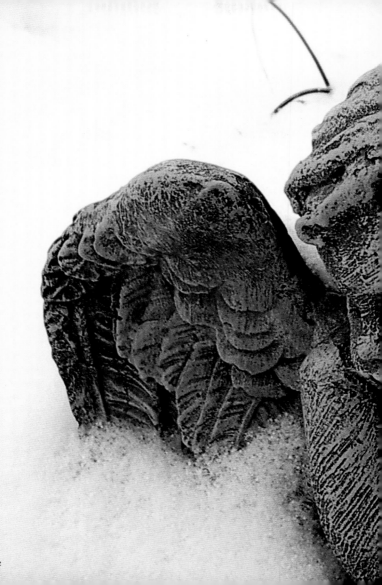

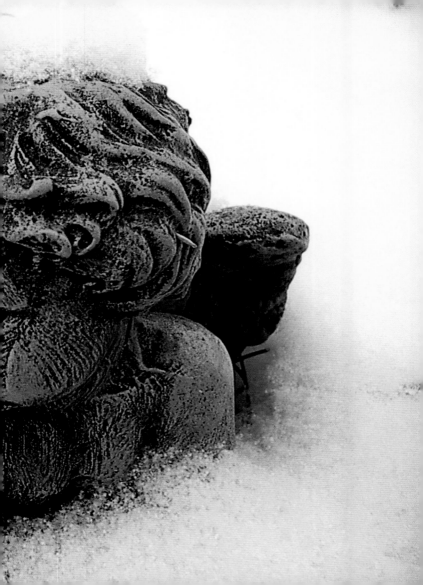

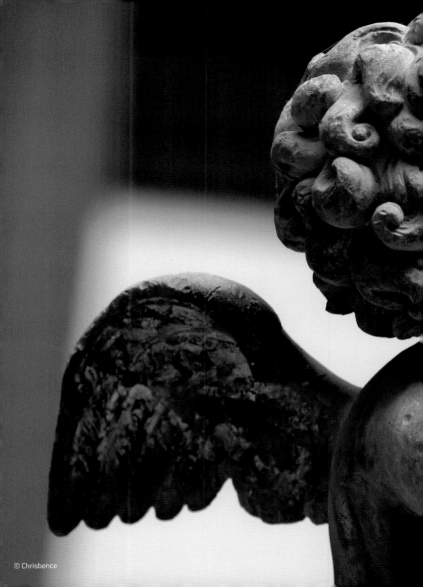

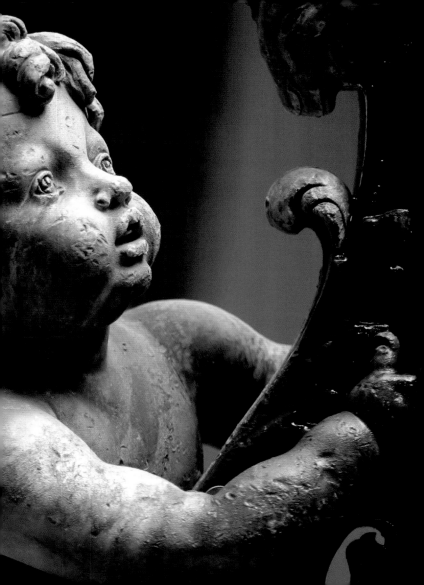

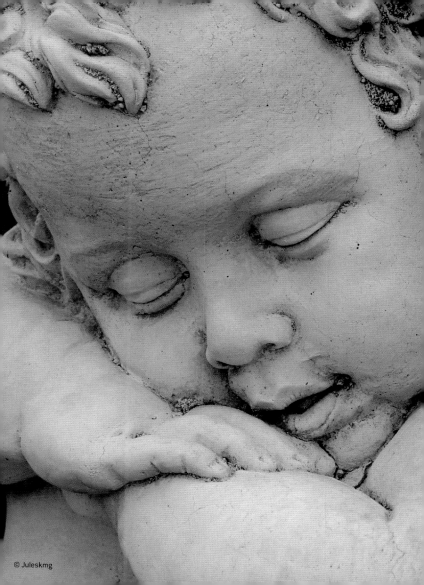

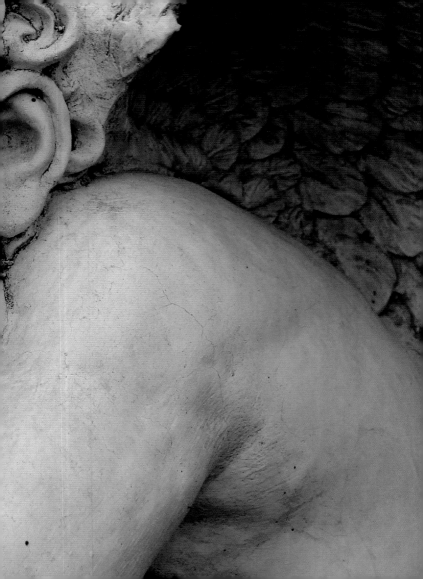

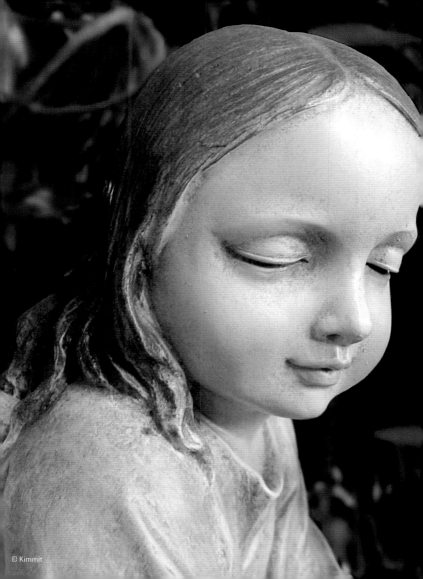

© Kimmit

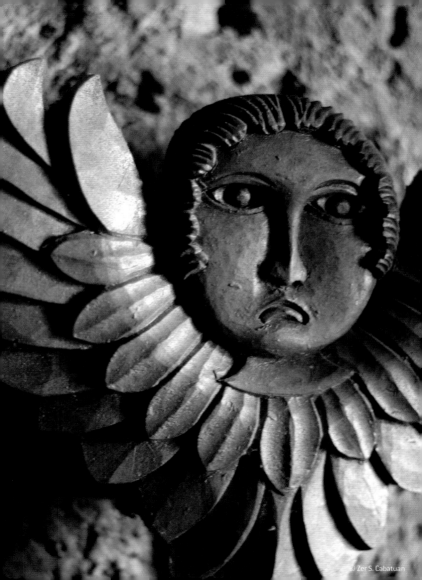

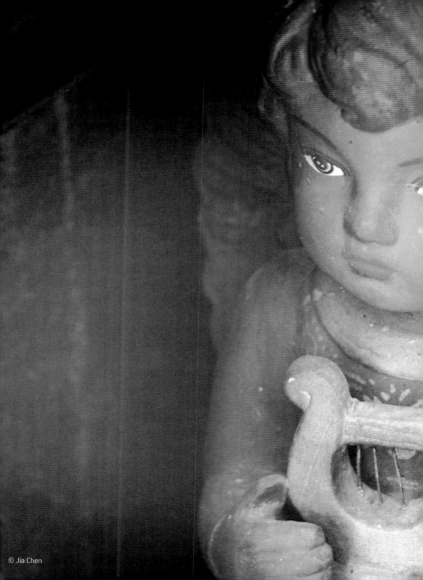

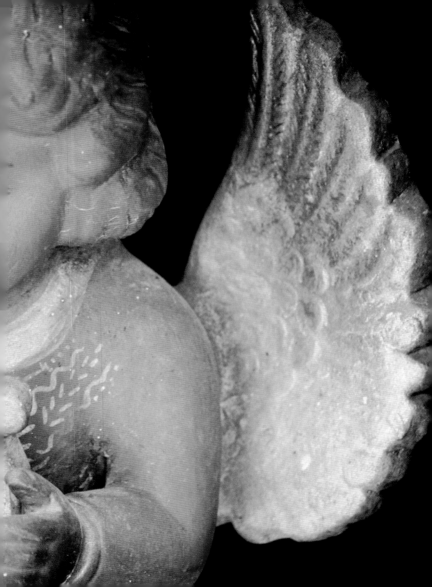

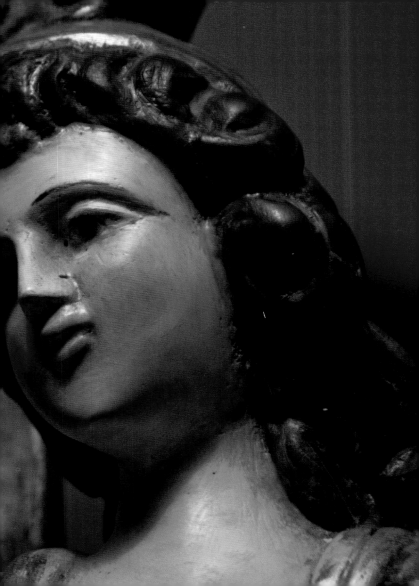

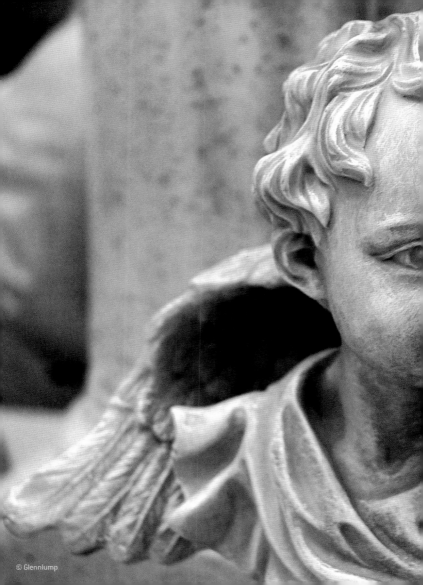

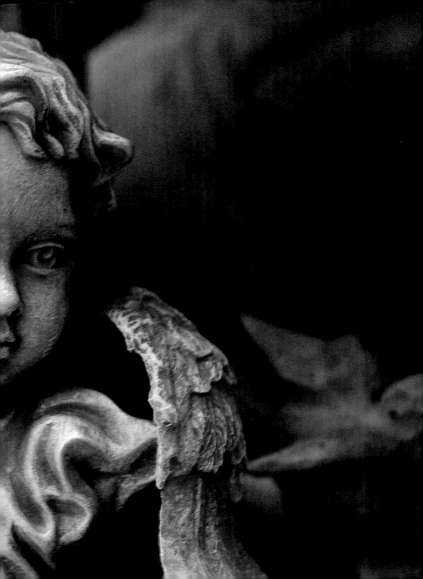

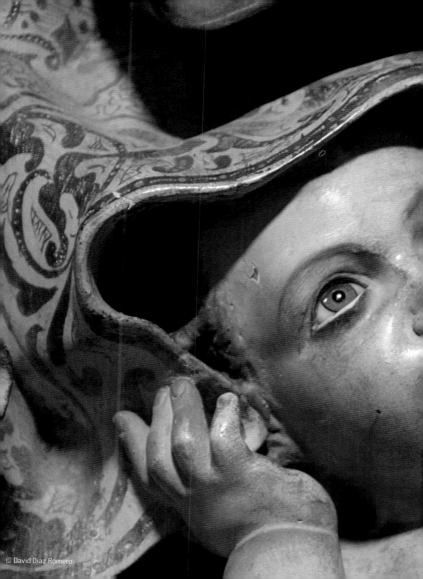

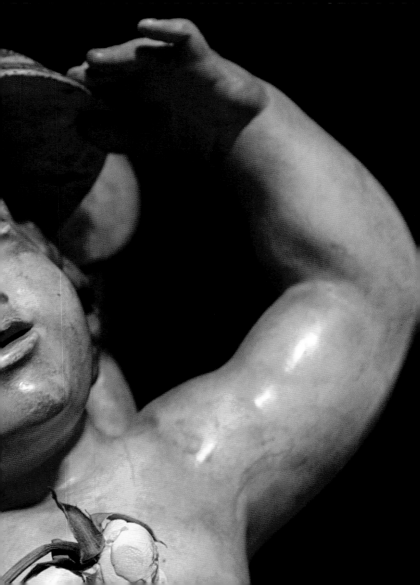

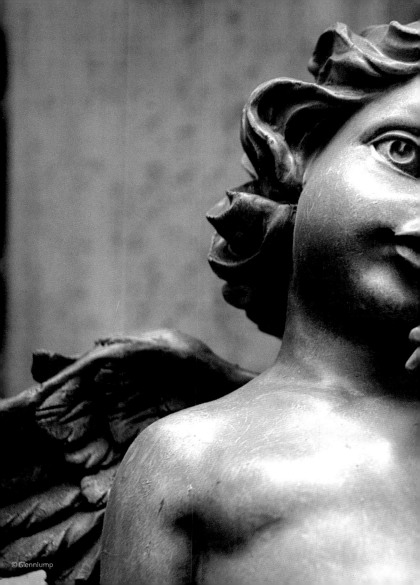

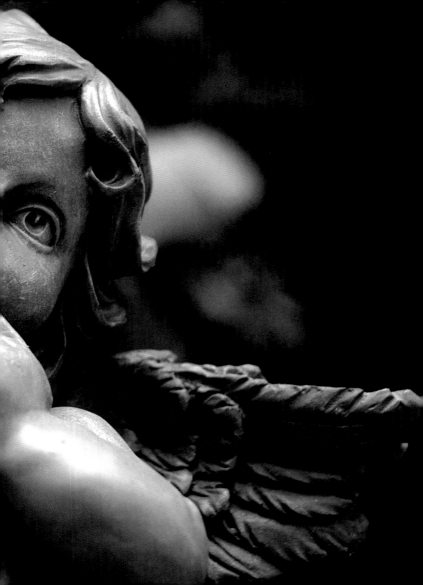

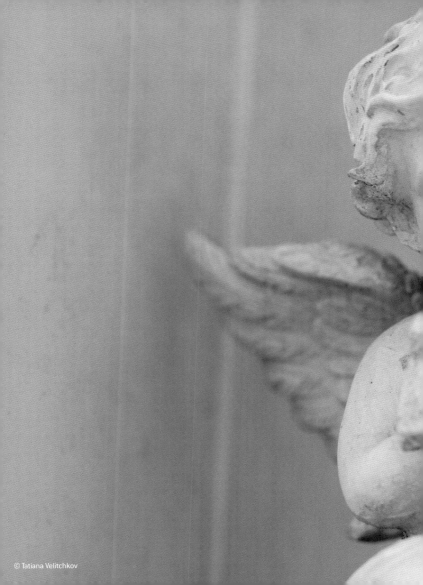

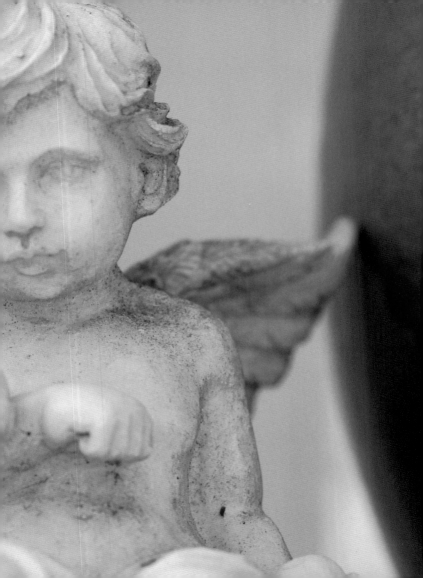

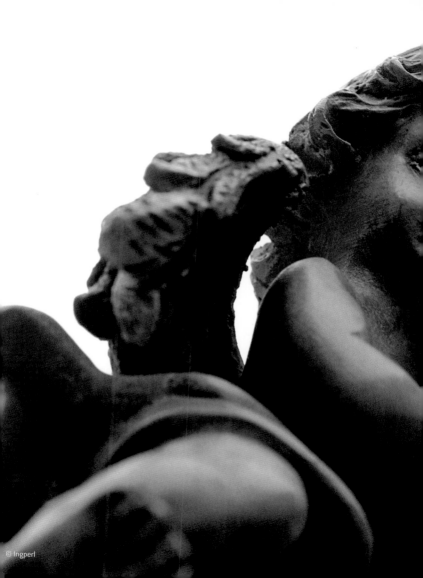

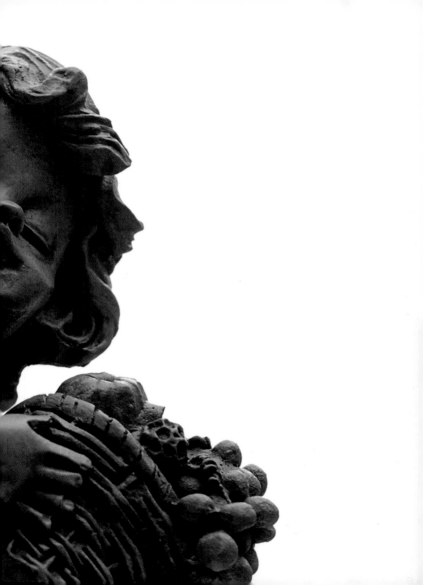

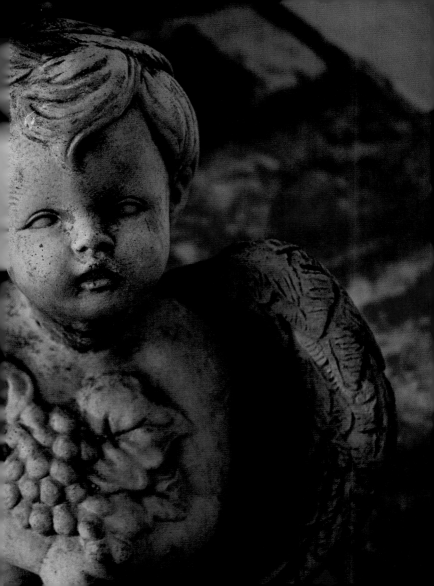

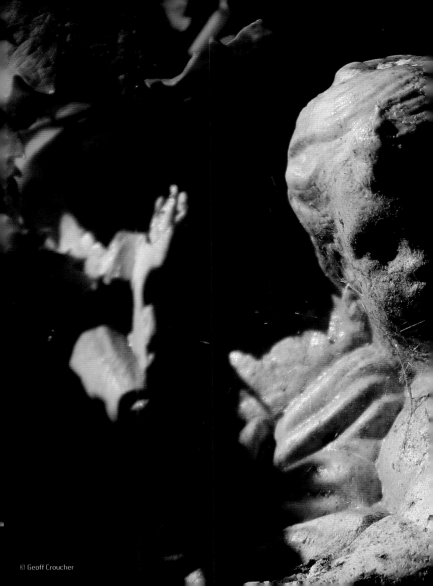

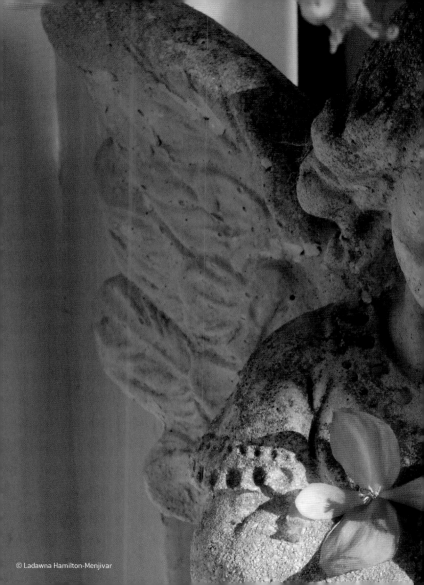

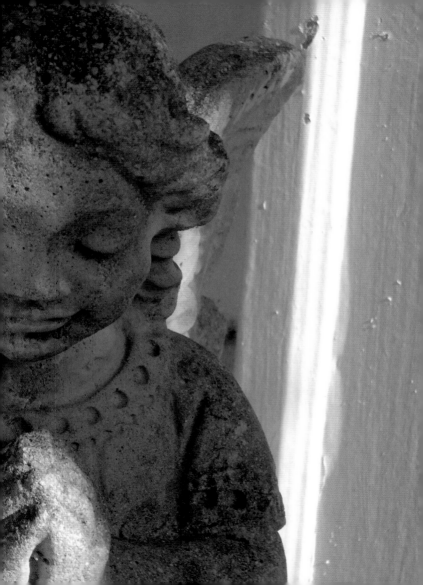

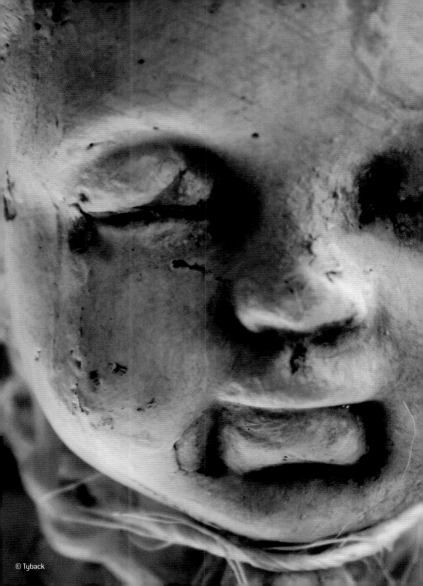

© Tyback

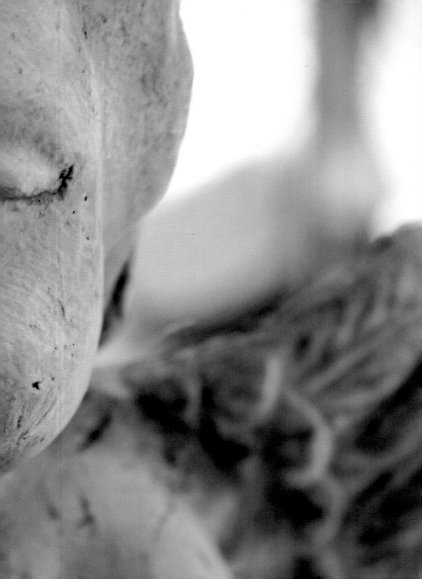

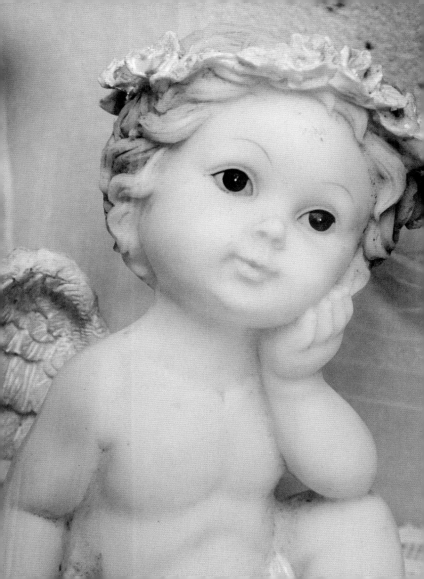

© Berenice Abbot

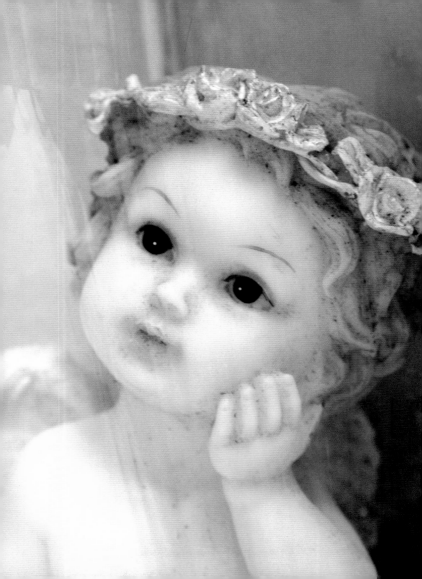

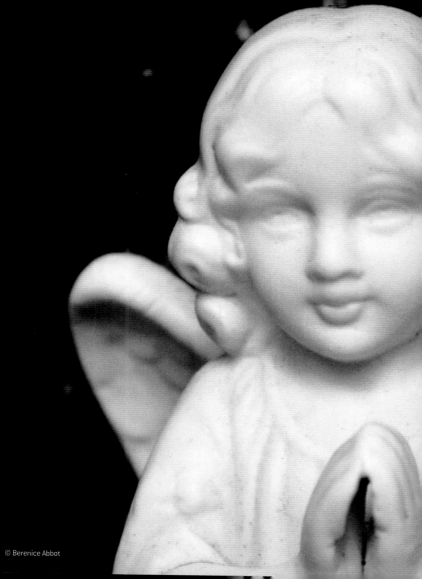

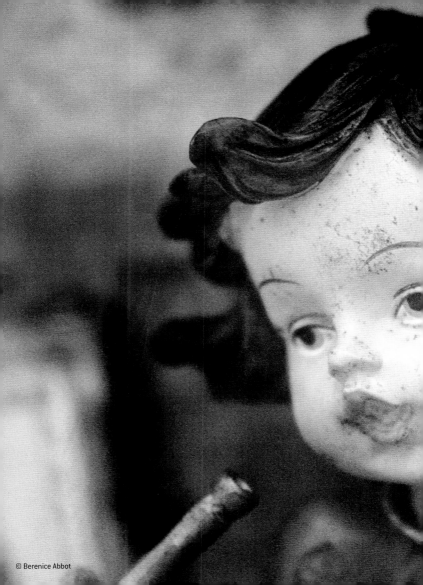

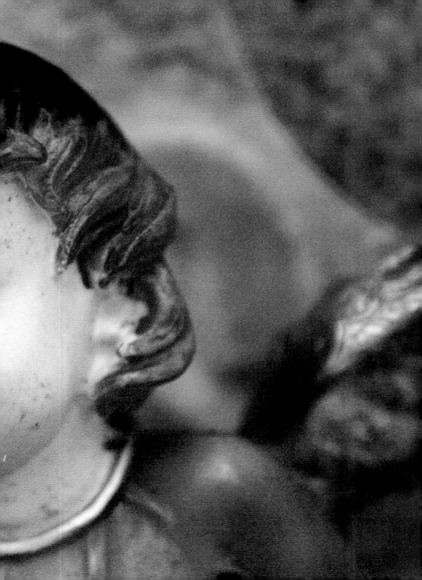

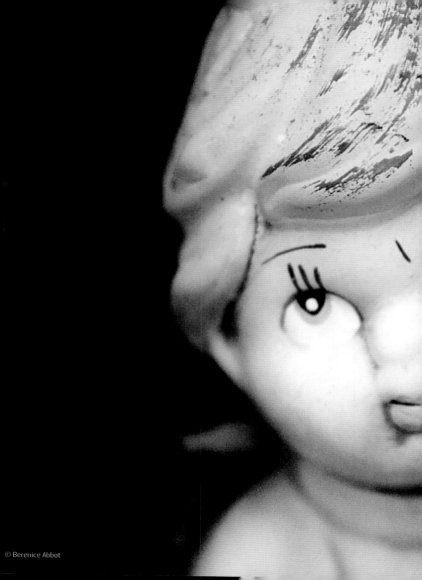

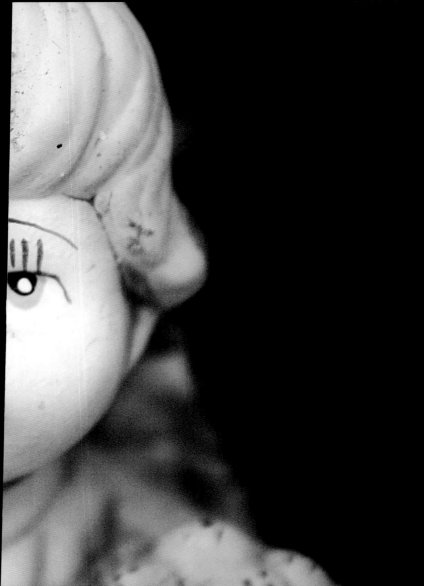

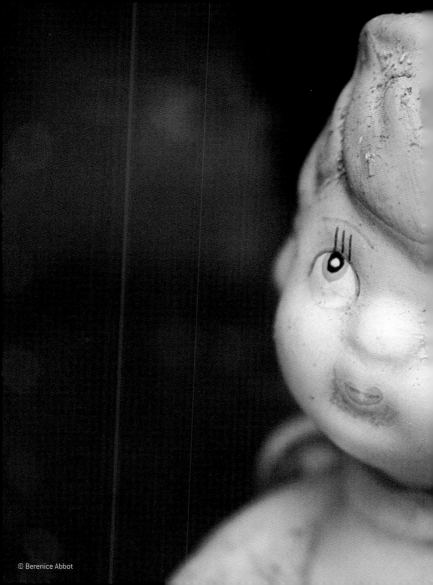

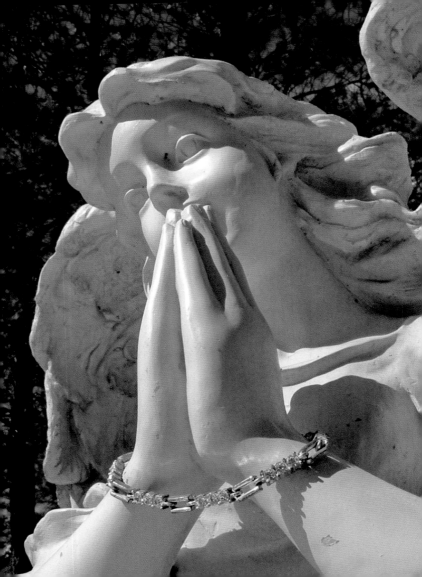

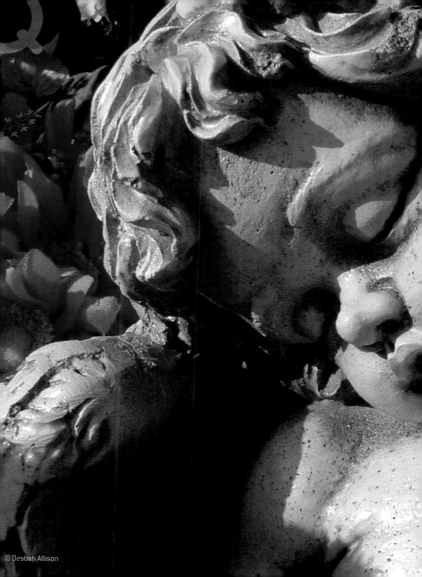

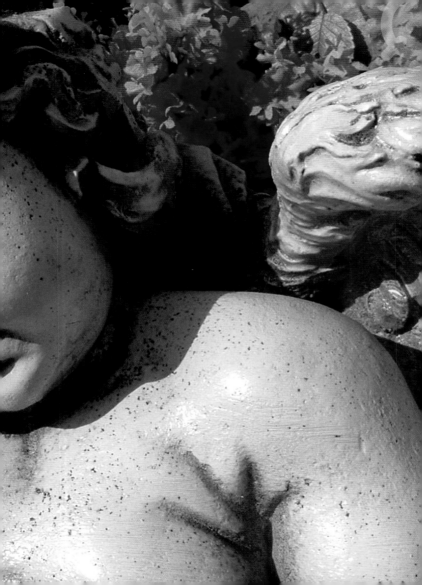

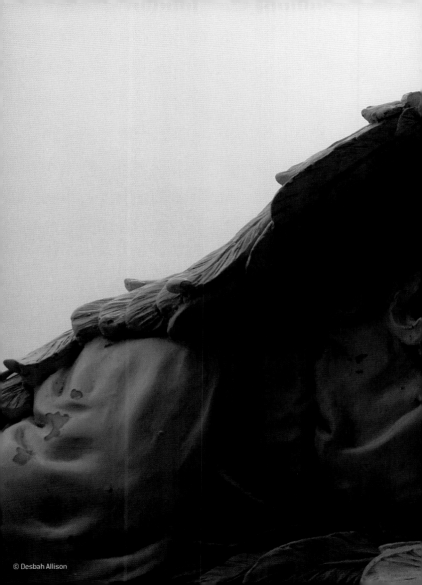
© Desbah Allison

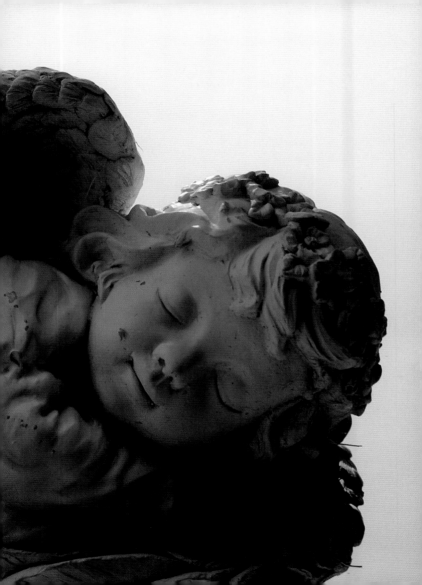

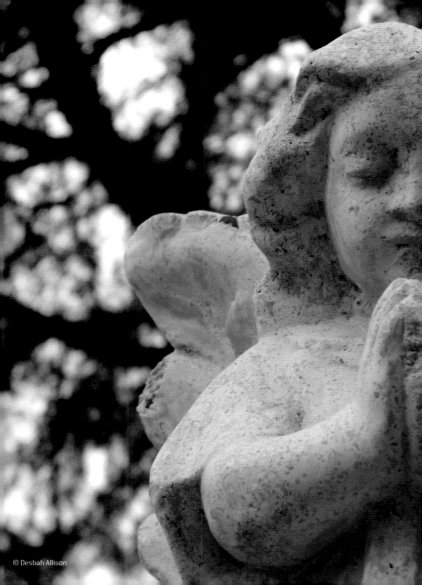

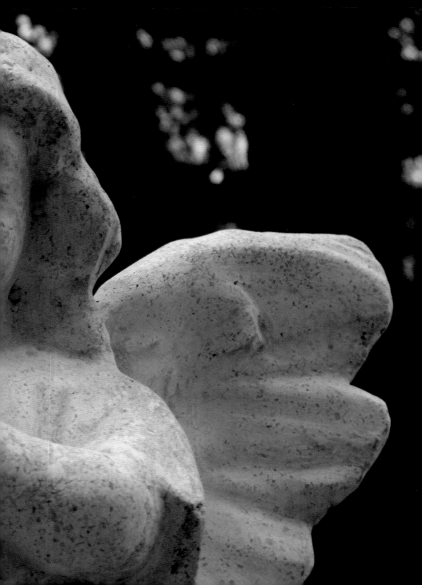

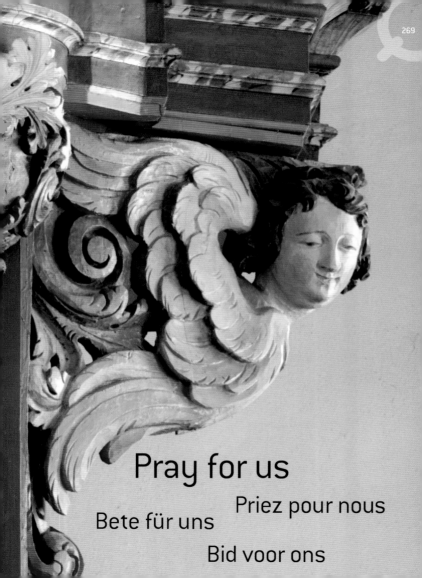

Pray for us

Priez pour nous

Bete für uns

Bid voor ons

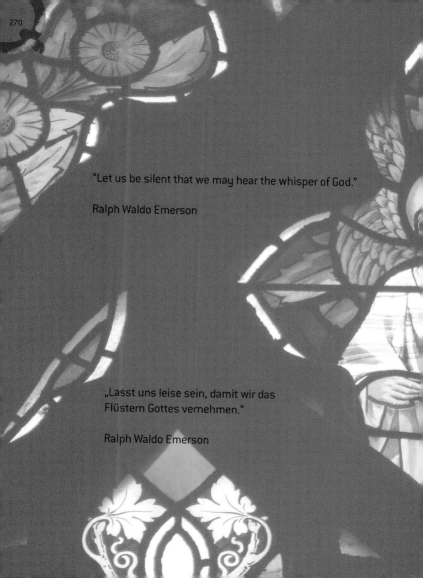

"Let us be silent that we may hear the whisper of God."

Ralph Waldo Emerson

„Lasst uns leise sein, damit wir das
Flüstern Gottes vernehmen."

Ralph Waldo Emerson

« Gardons le silence de façon à pouvoir entendre le murmure de Dieu. »

Ralph Waldo Emerson

"Laten we stil zijn zodat we het ge-
fluister van God kunnen horen."

Ralph Waldo Emerson

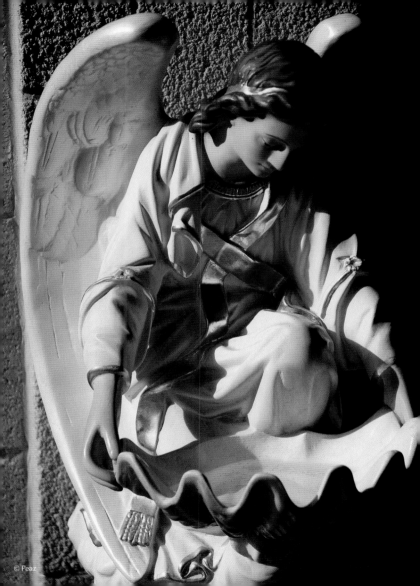
© Peaz

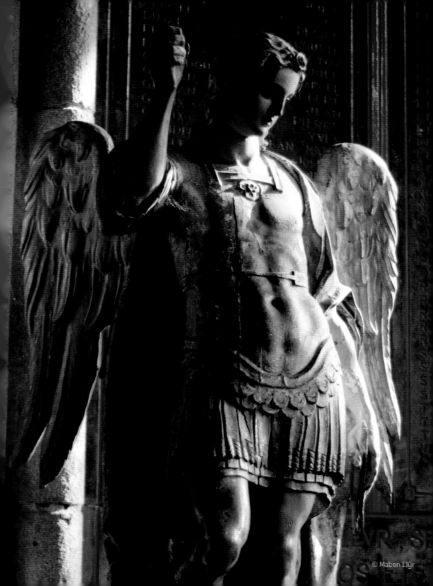

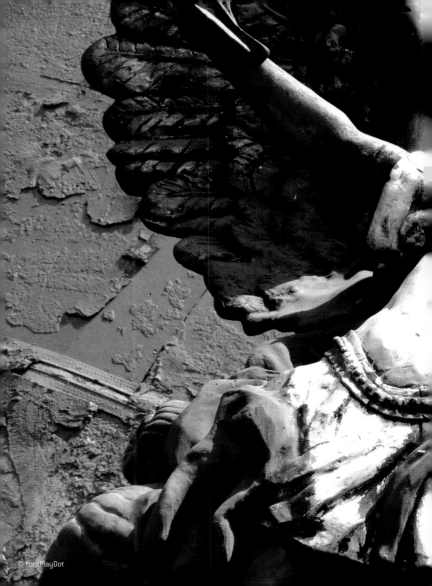

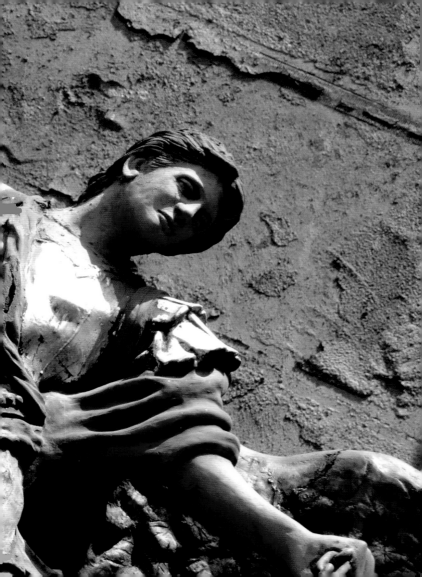

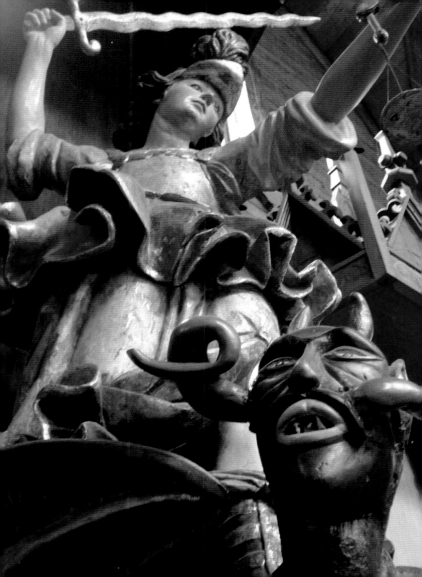

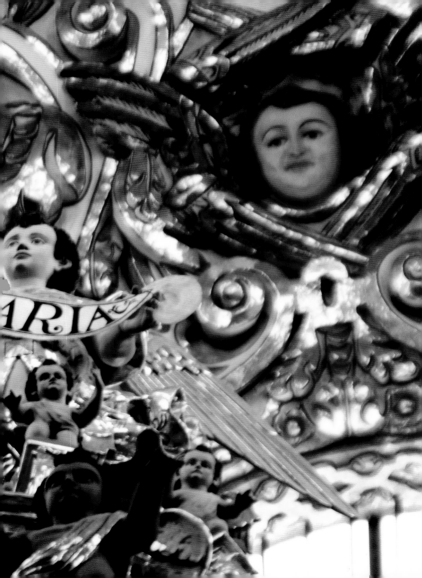

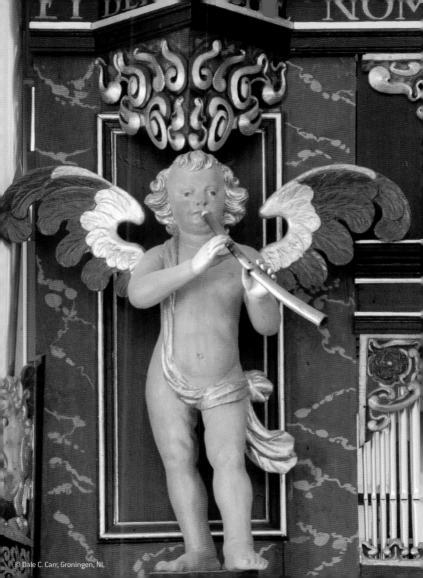

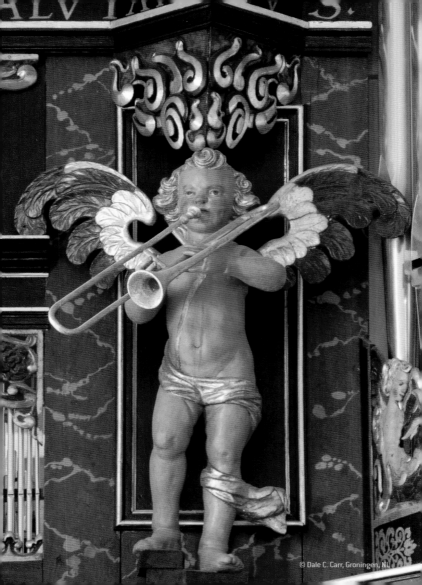

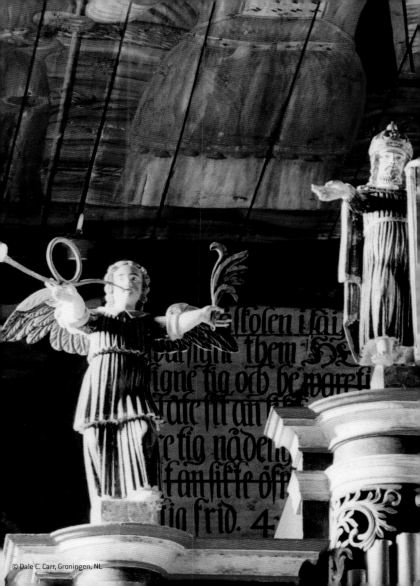

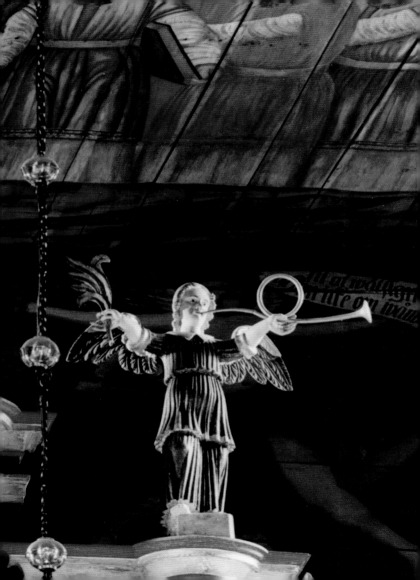

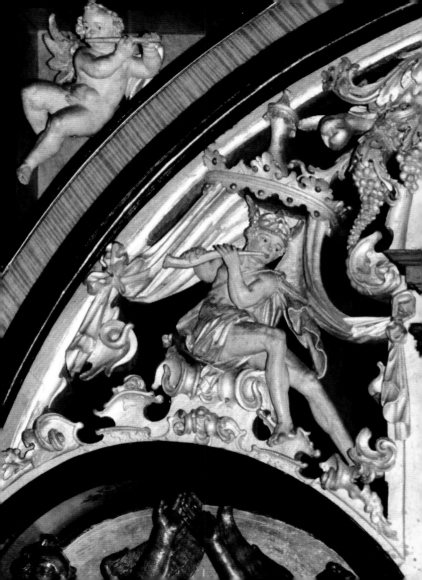

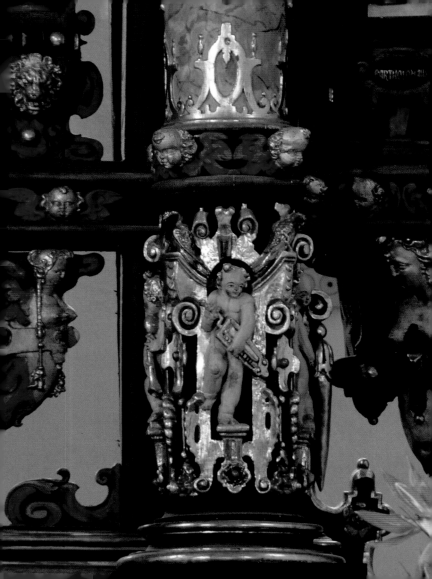

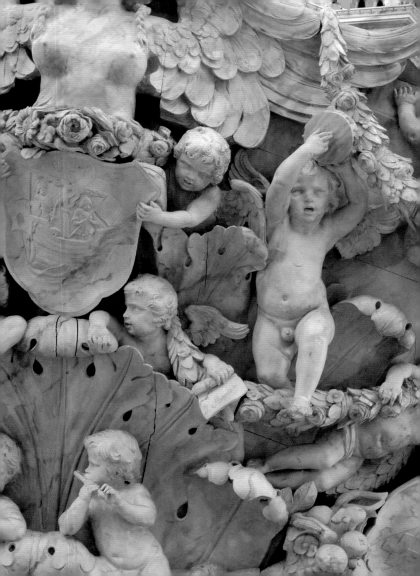

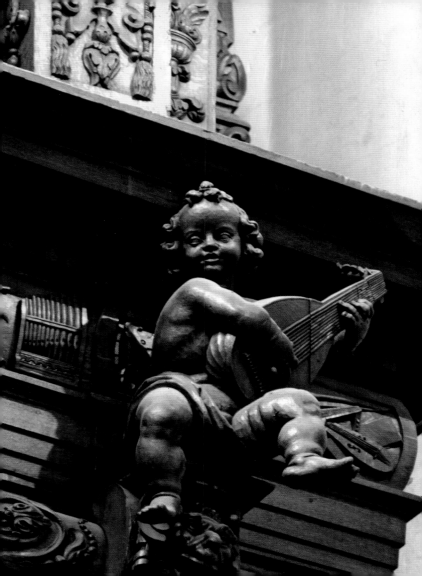

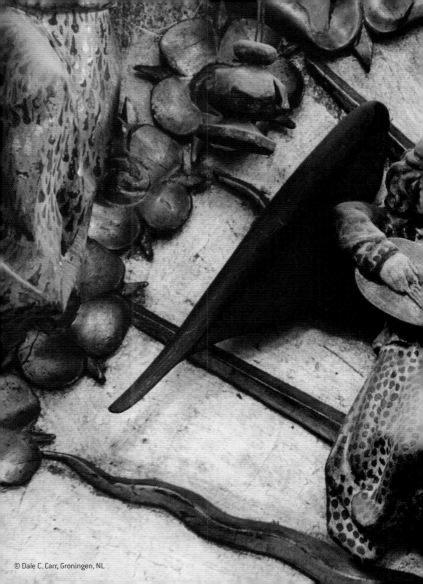
© Dale C. Carr, Groningen, NL

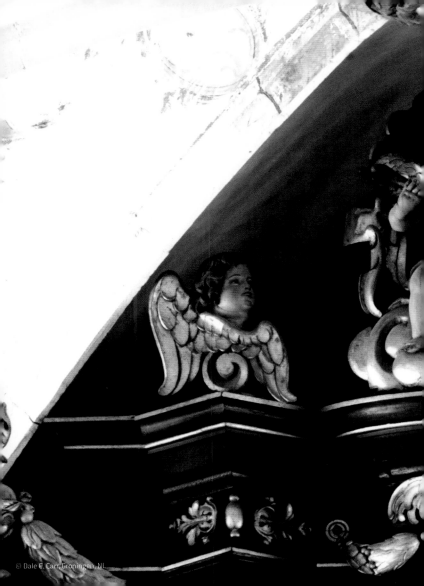

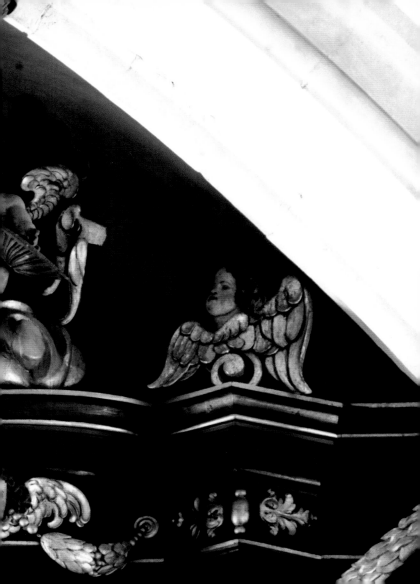

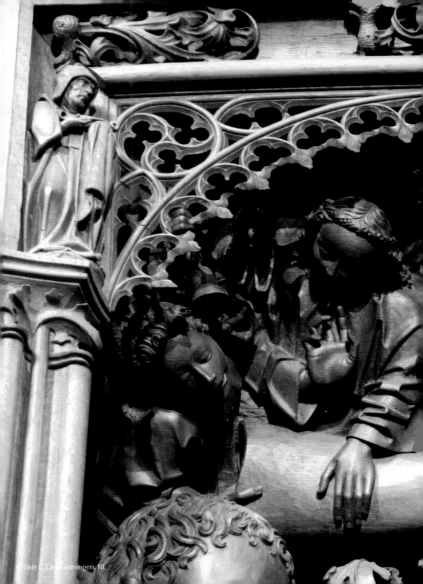

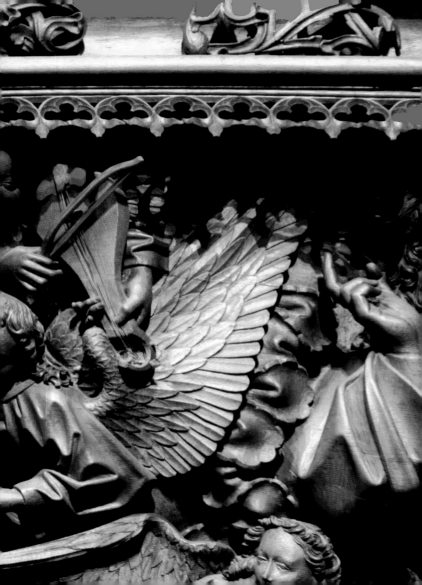

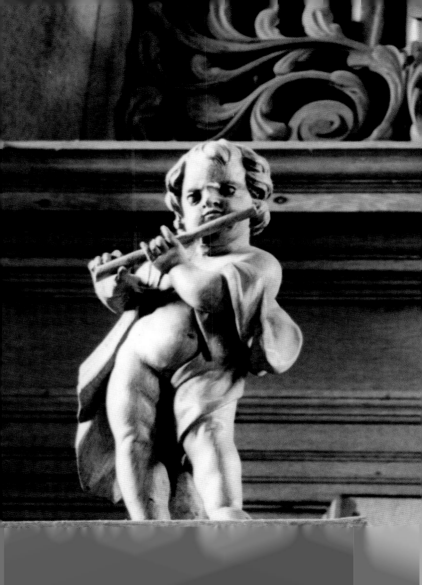

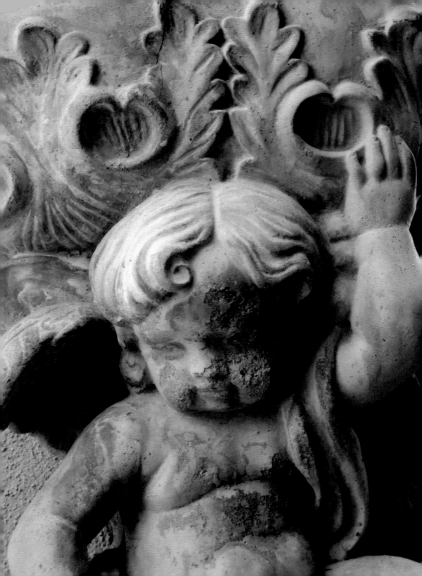

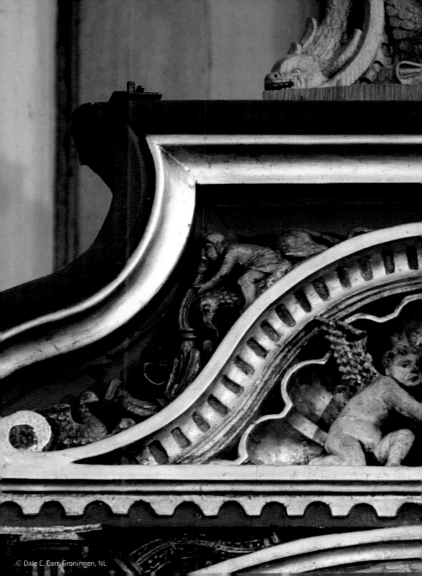

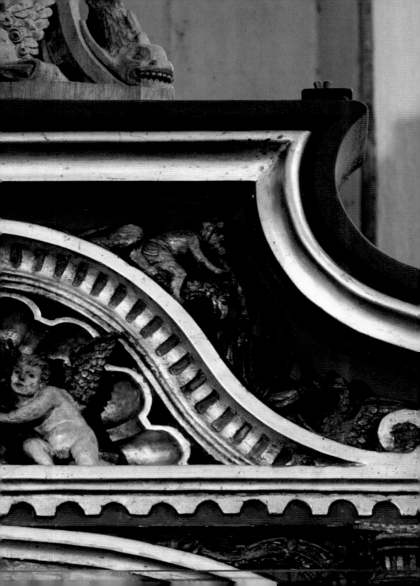

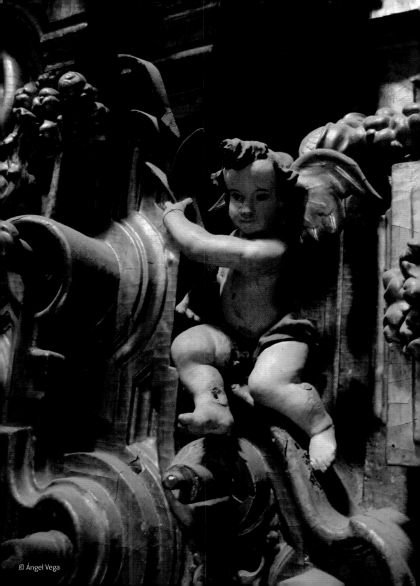

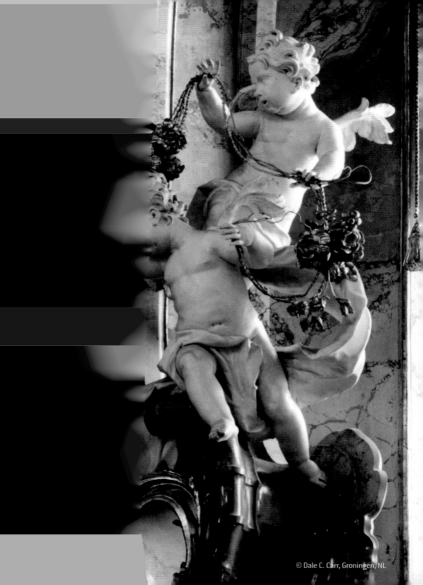

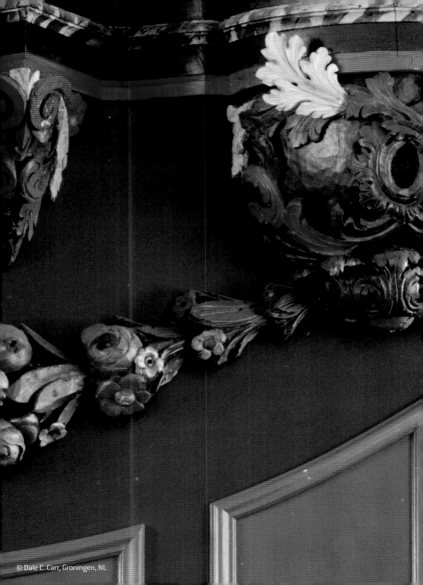

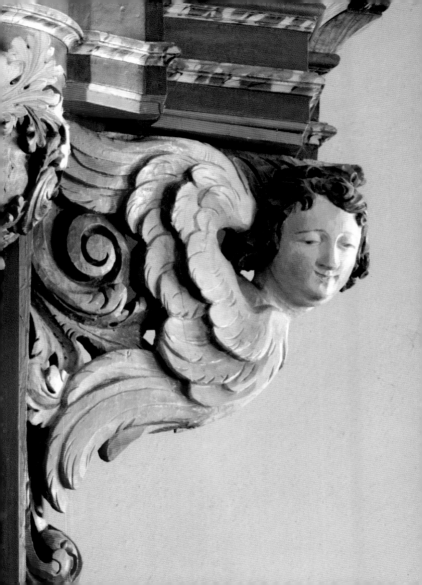

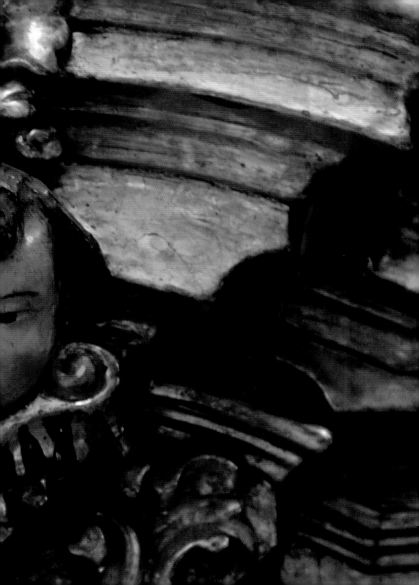

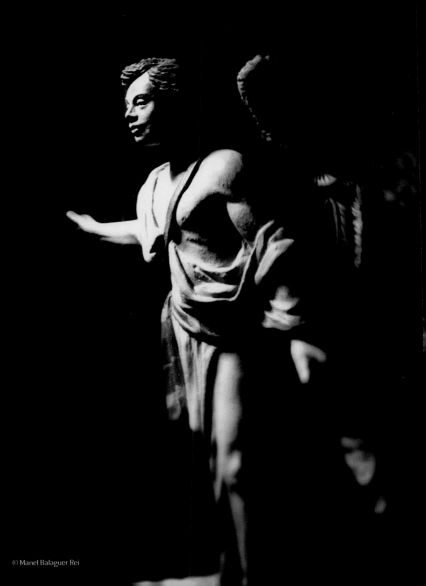

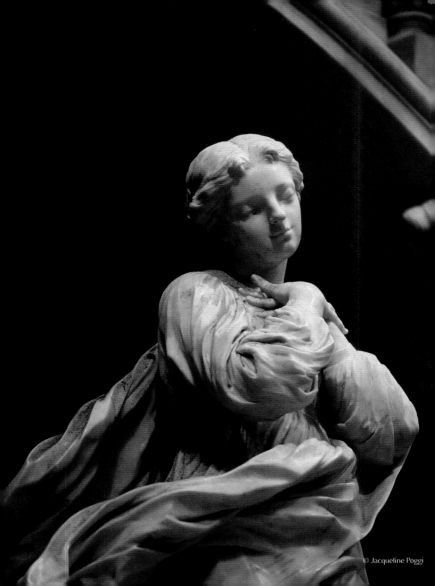

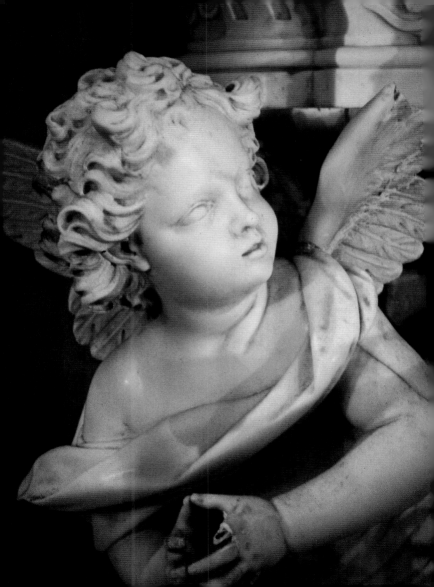

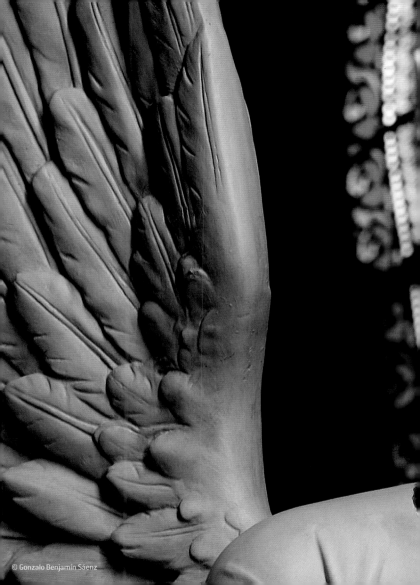

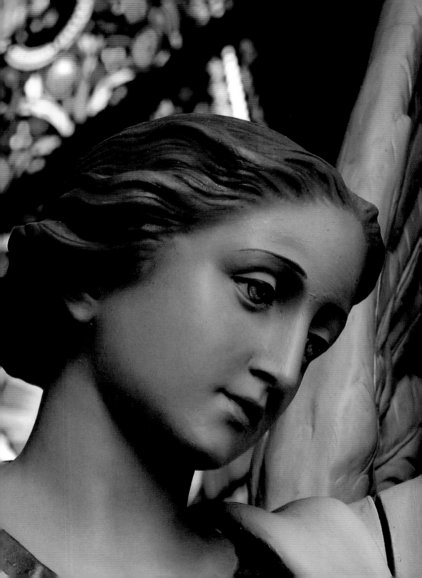

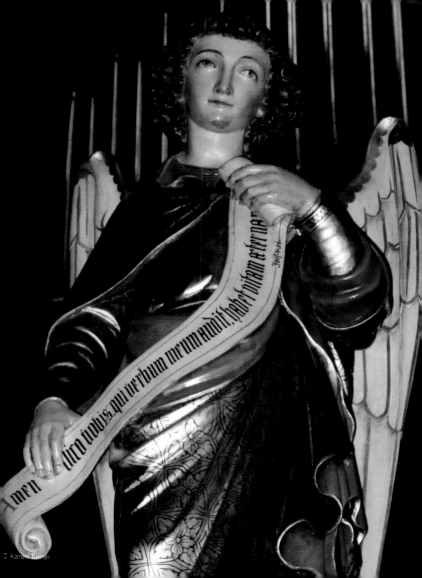

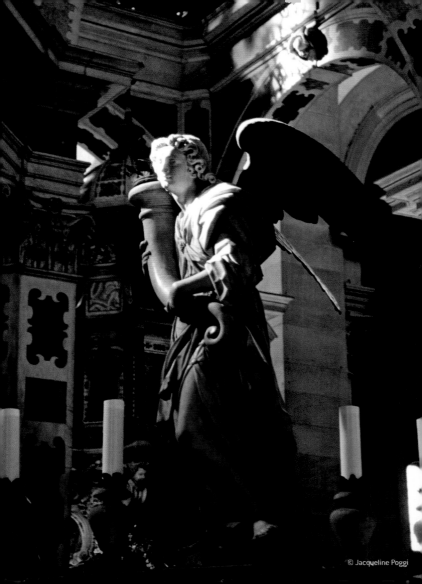

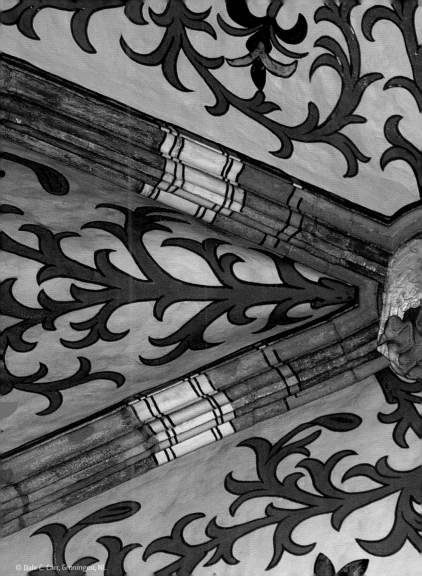

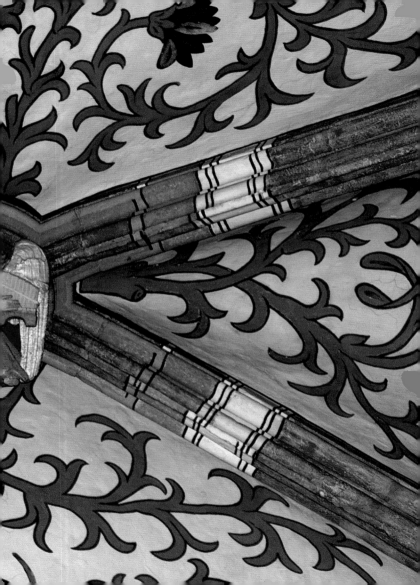

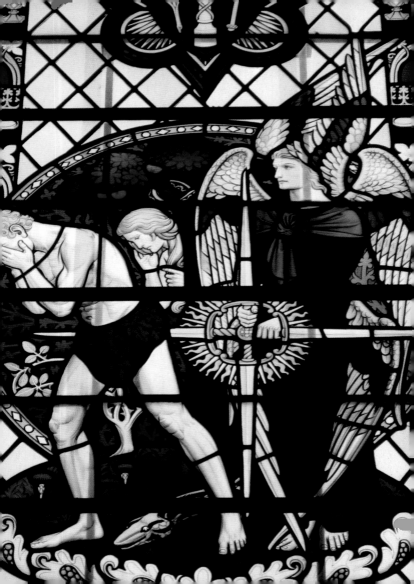

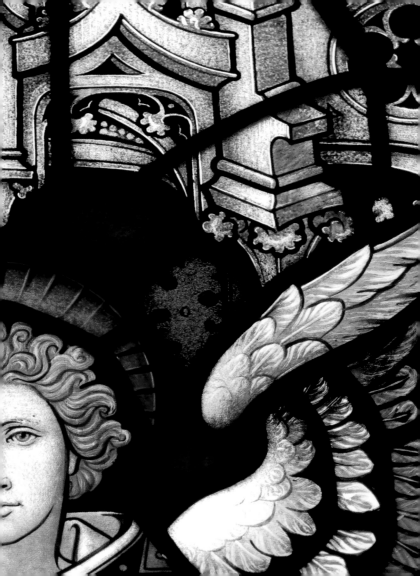

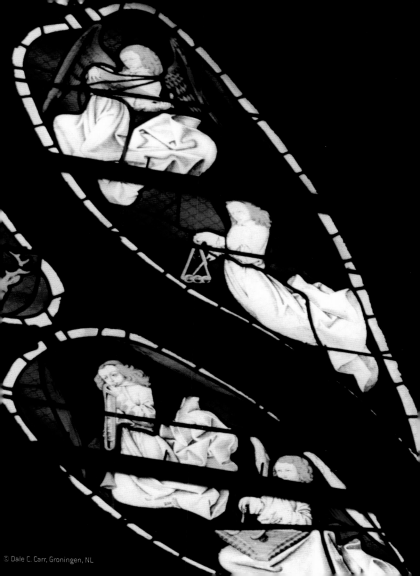

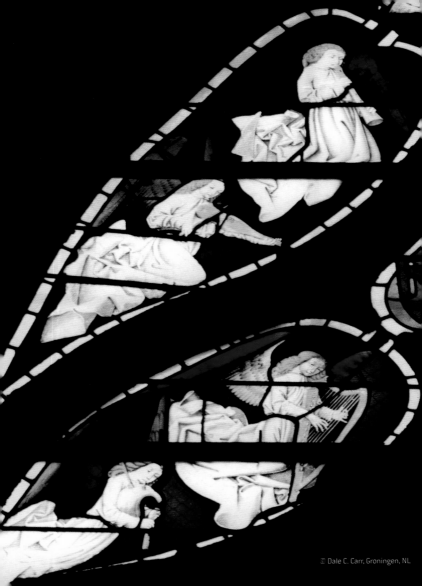

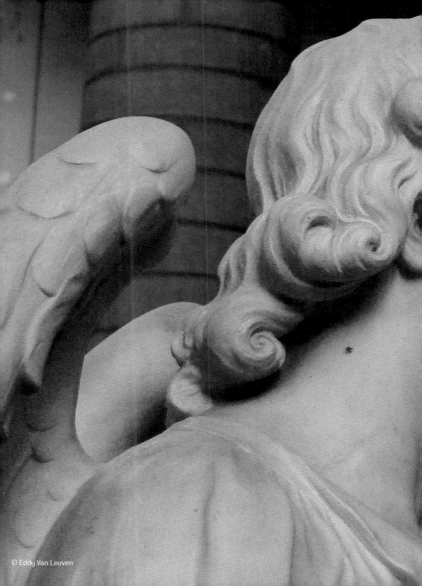

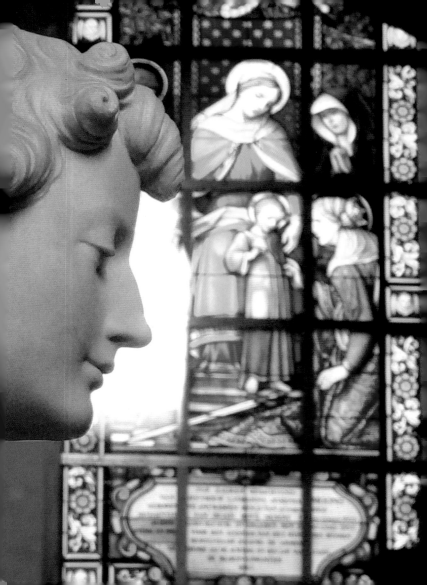

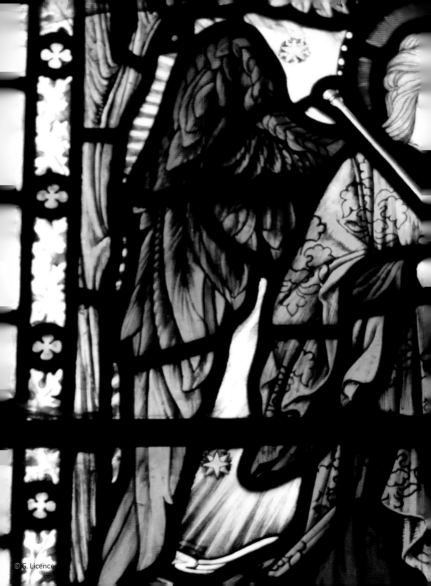

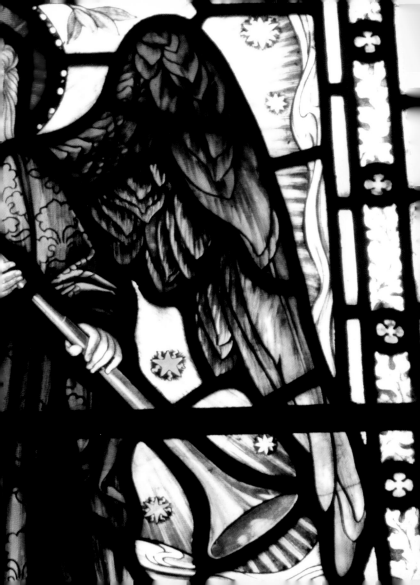

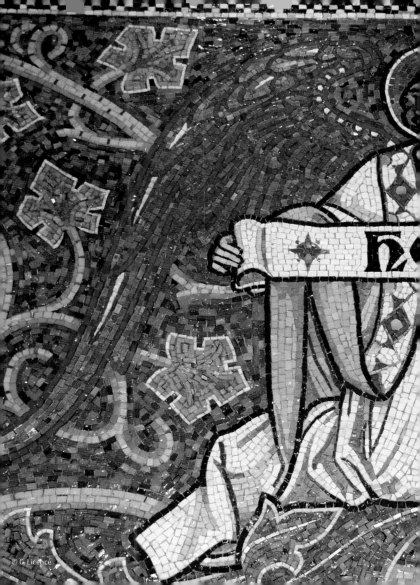

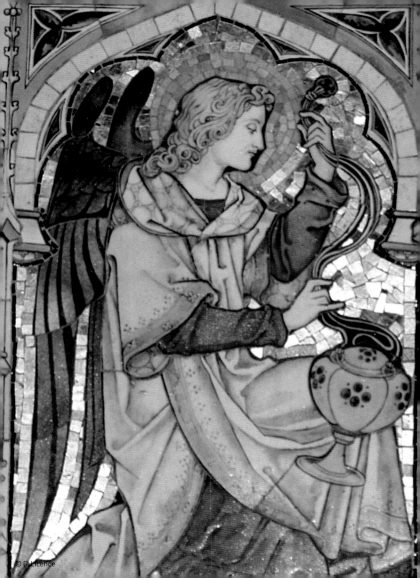

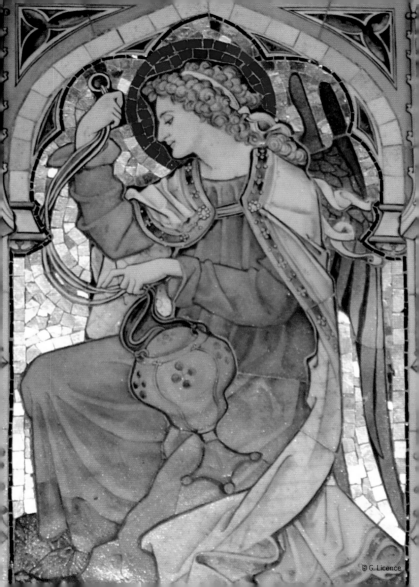

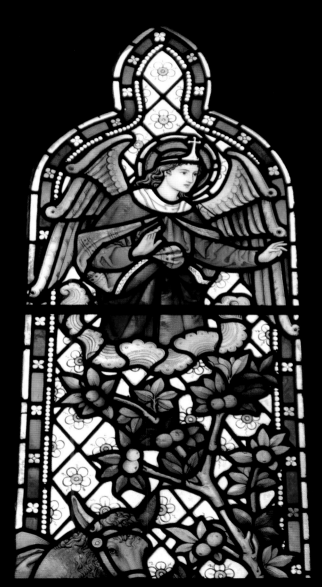

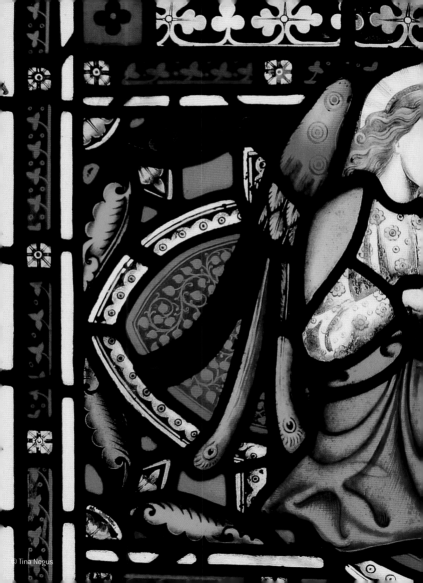

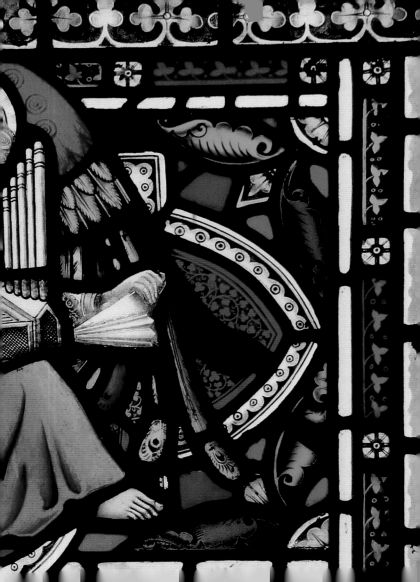

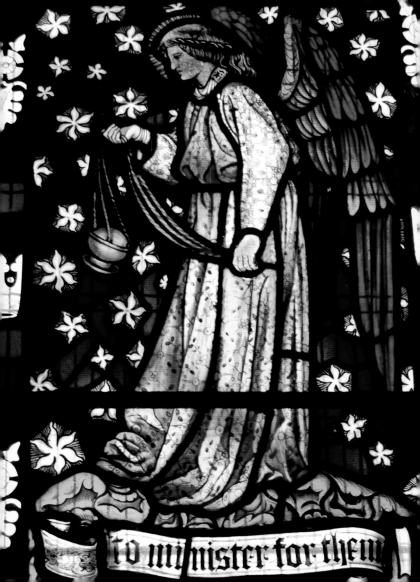

to minister for them

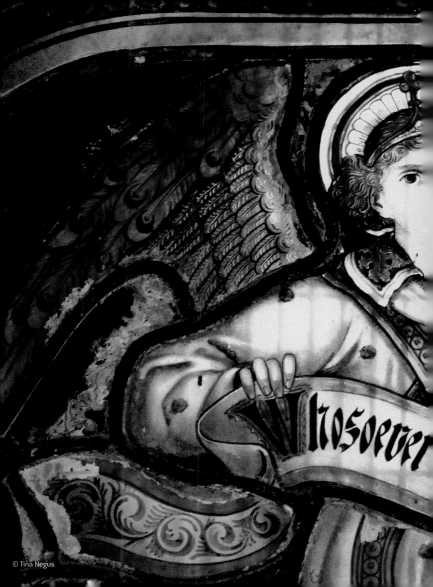

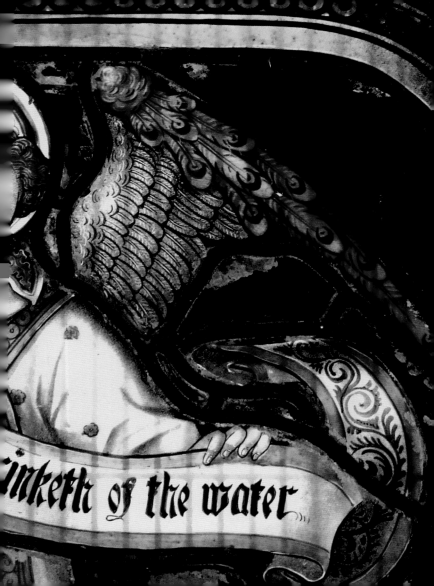

© Tina Negus

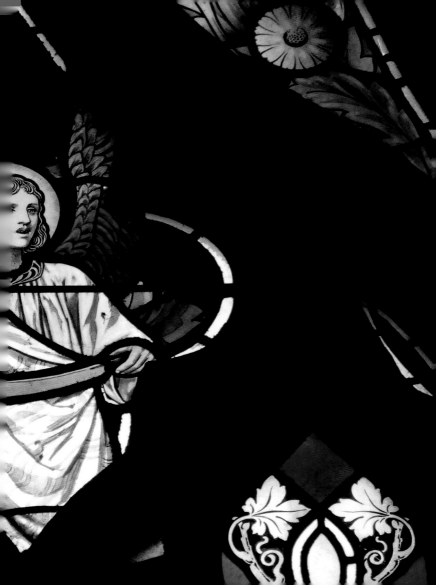

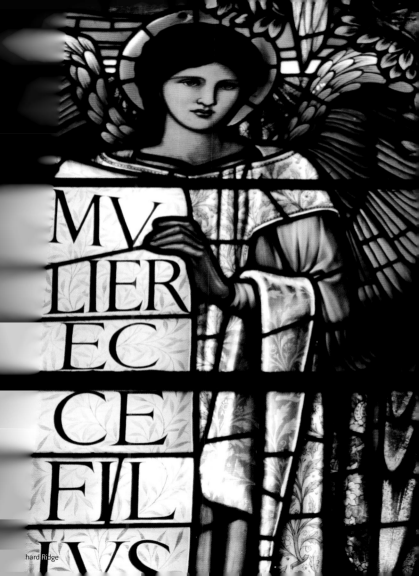

MV
LIER
EC
CE
FIL
IVS

hard Ridge

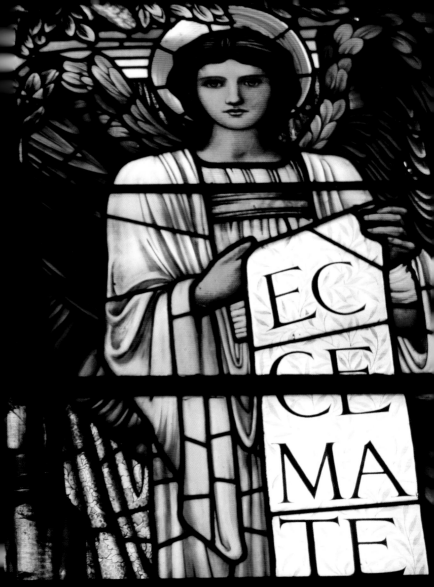

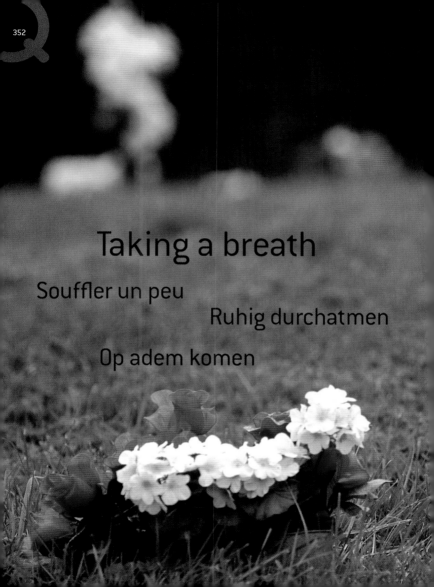

Taking a breath

Souffler un peu

Ruhig durchatmen

Op adem komen

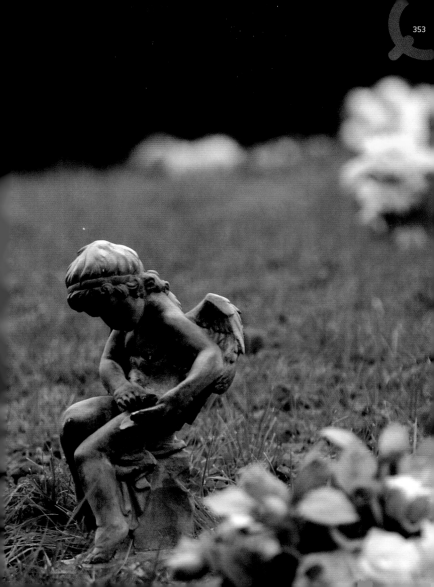

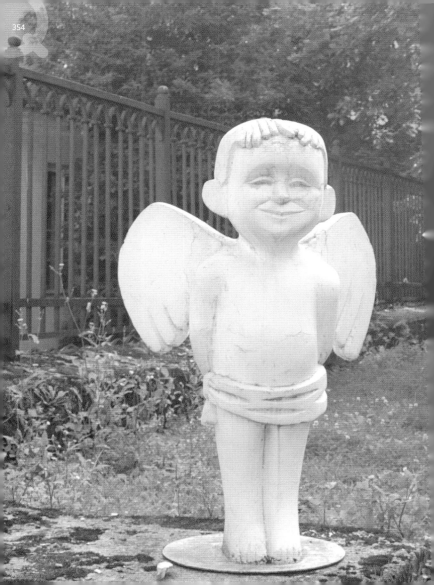

"Every blade of grass has an angel that bends over it and whispers, 'grow! grow!'."

The Talmud

« Au-dessus de chaque brin d'herbe il y a un ange qui s'incline et murmure : Pousse, pousse ! »

Le Talmud

„Jeder Grashalm hat seinen Engel, der sich über ihn beugt und ihm zuflüstert: Wachse, wachse."

Talmud

"Elke grasspriet heeft een beschermengel die zich over hem heen buigt en fluistert: 'groei, groei!'."

De Talmoed

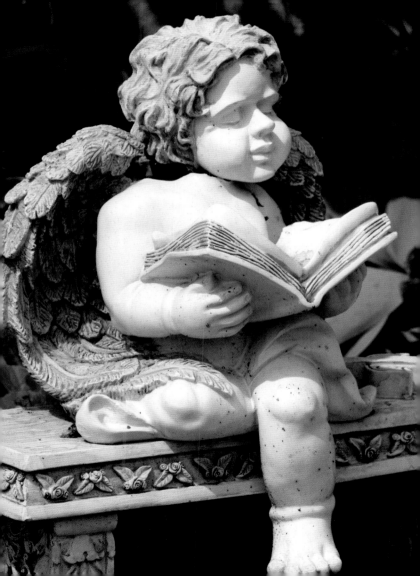

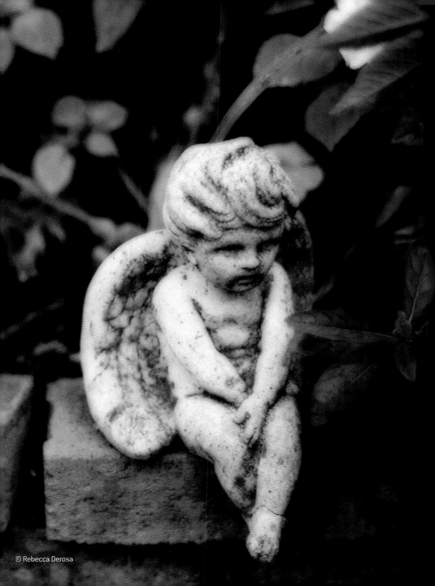

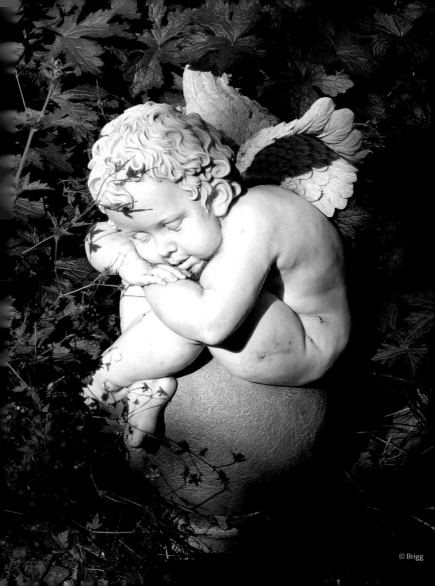

© Brigg

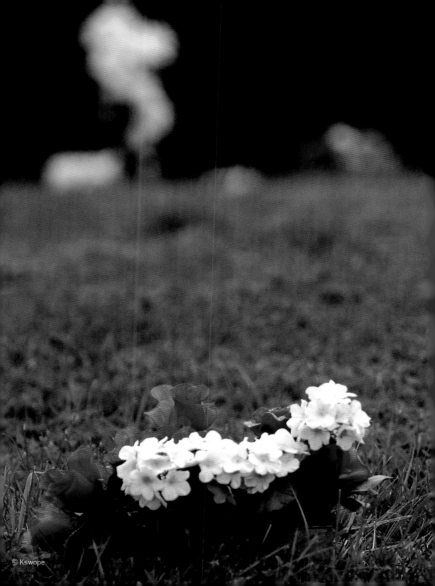

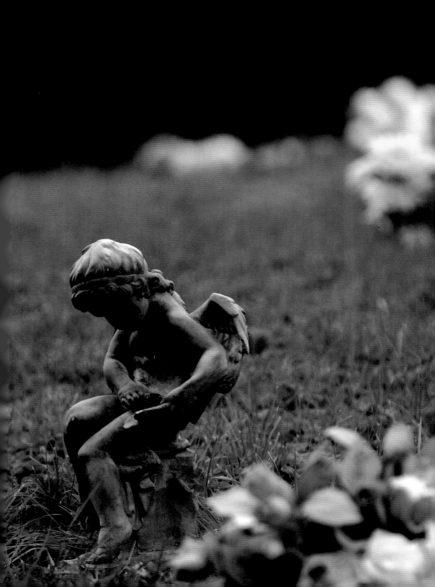

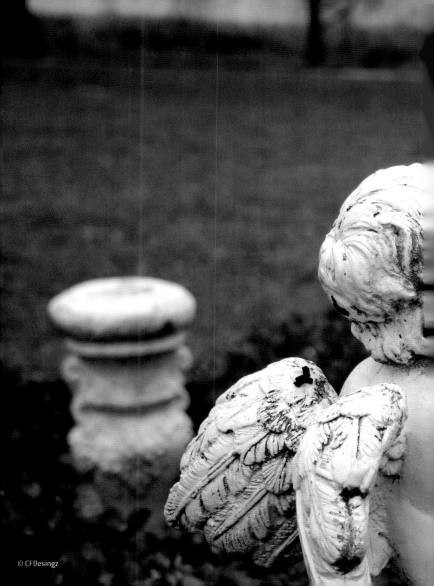

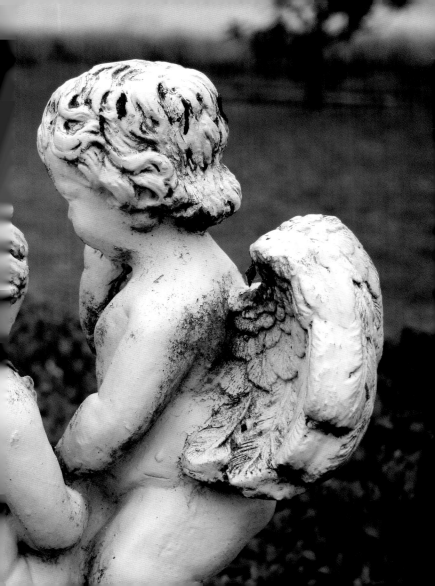

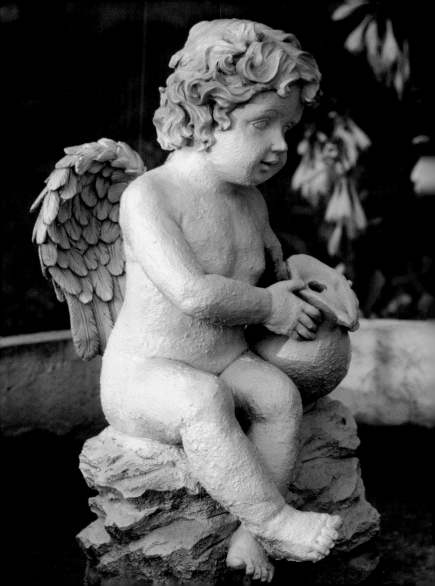

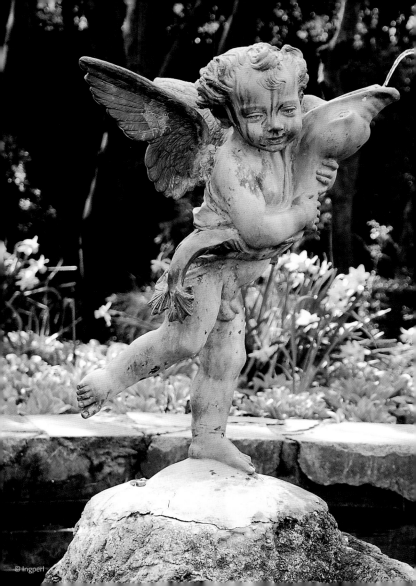

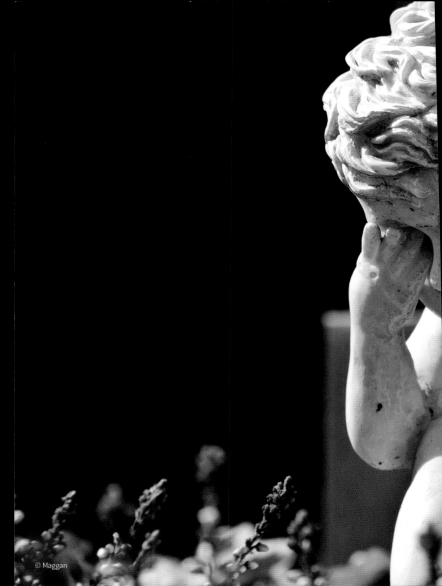

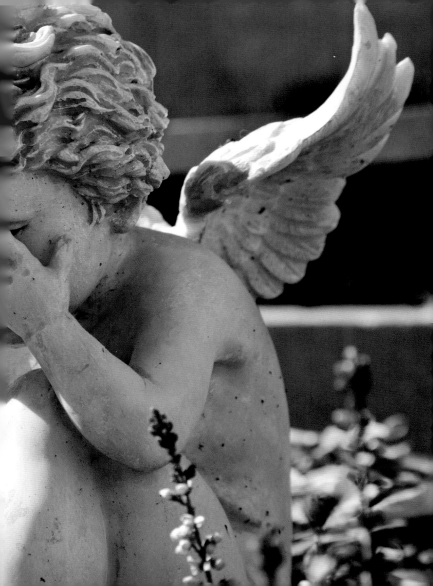

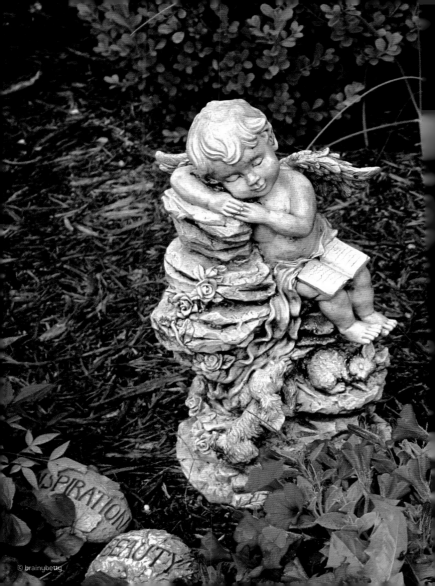

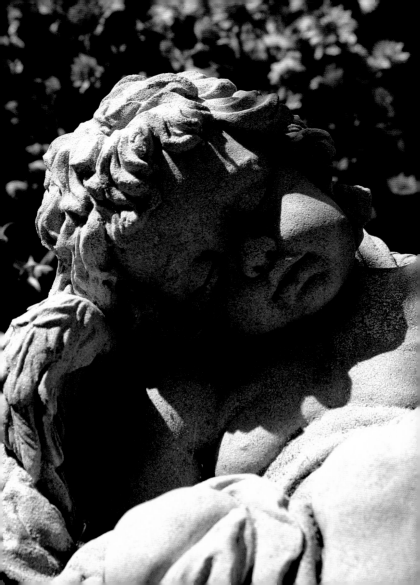

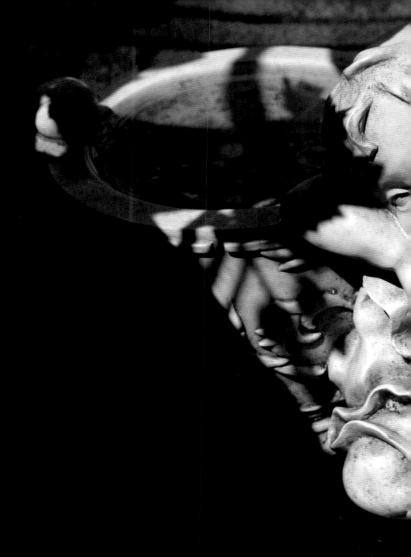

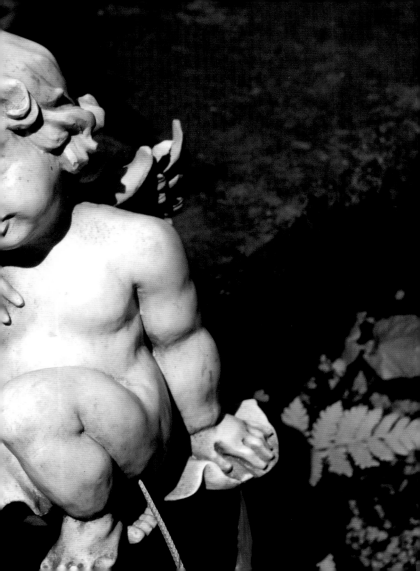

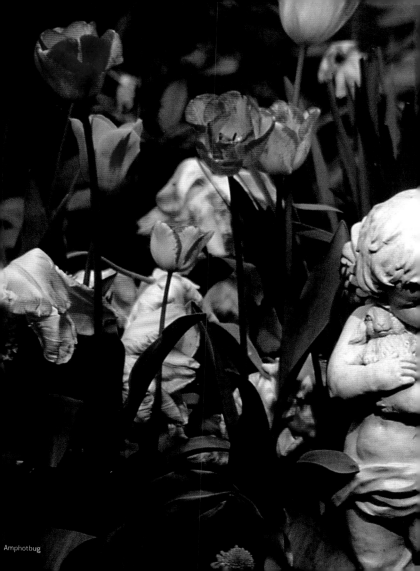

Amphotbug

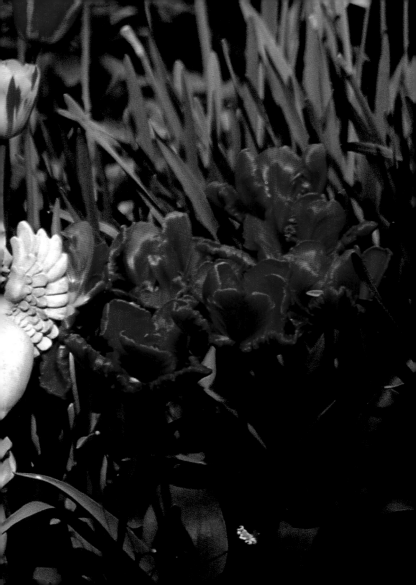

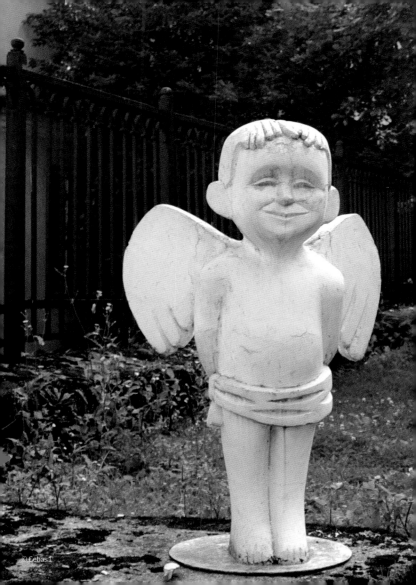

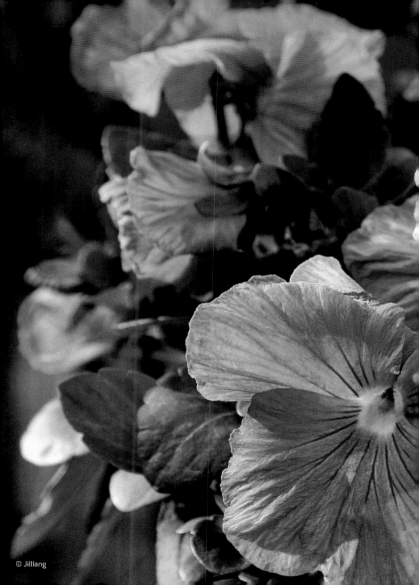
© Jilllang

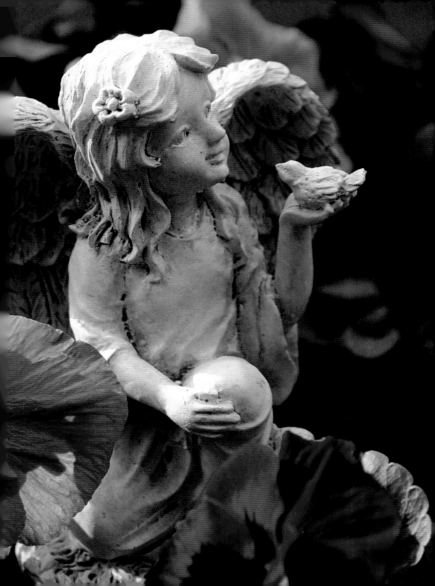

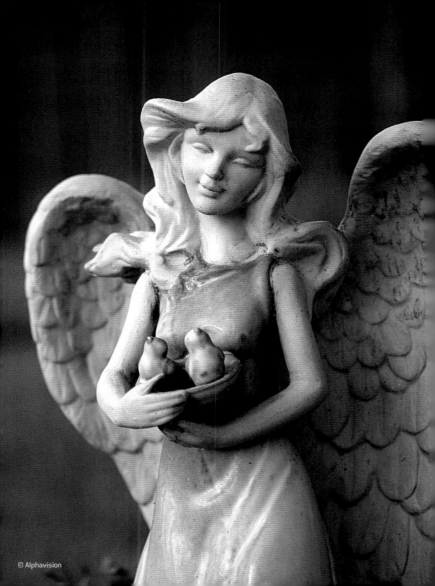

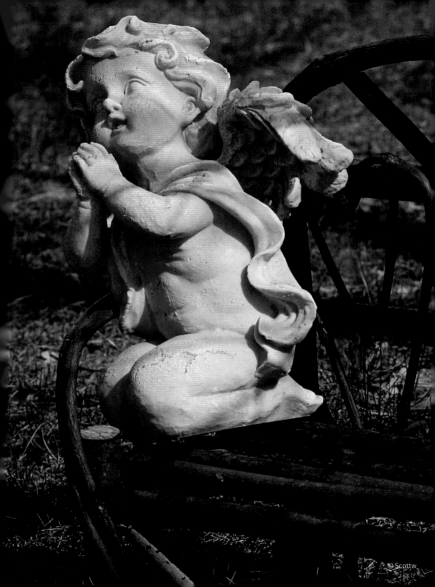

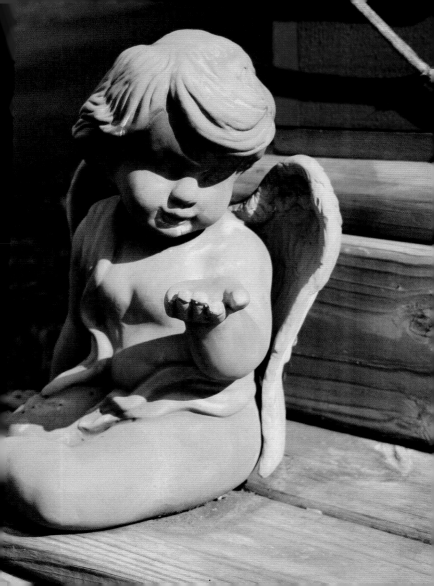

© Tom McCauley

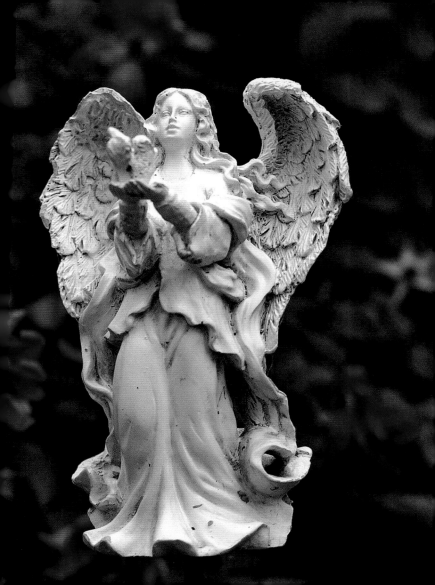

© Allen Lyons

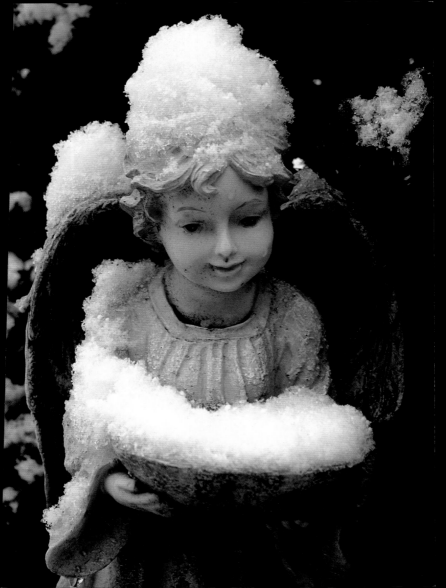

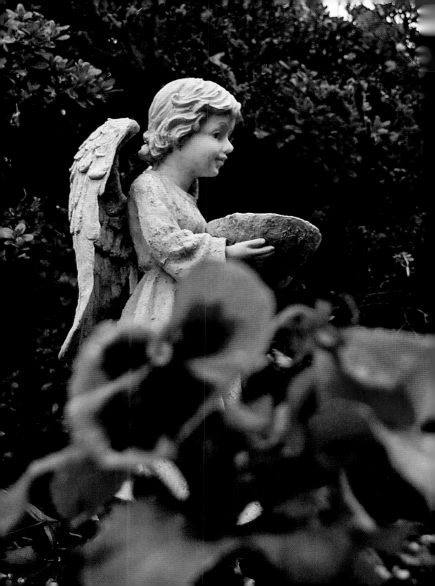

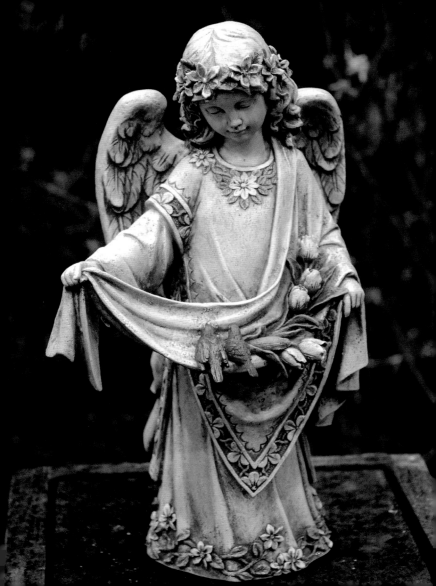

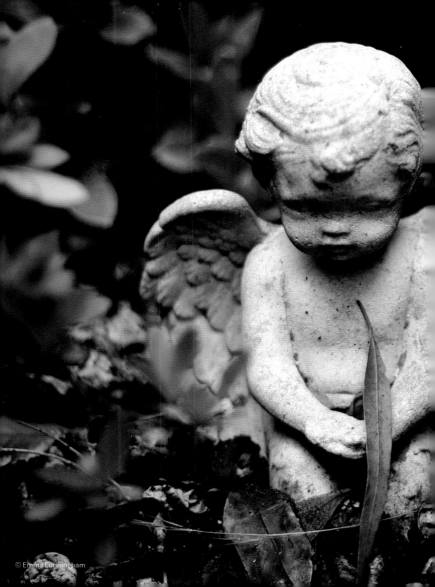

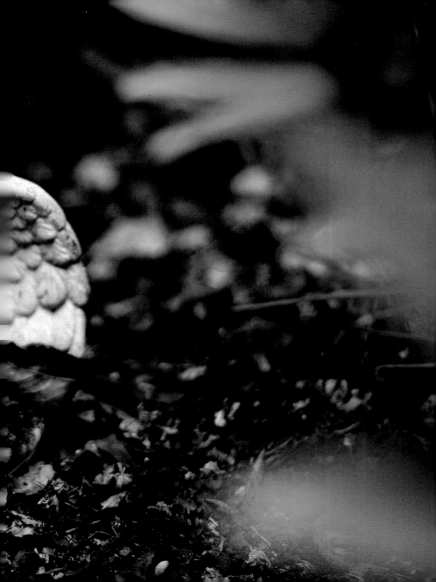

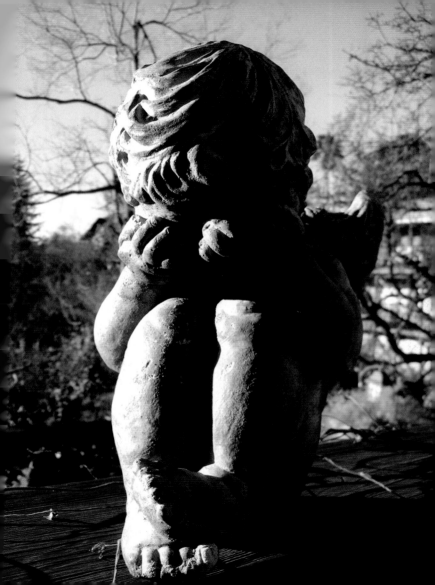

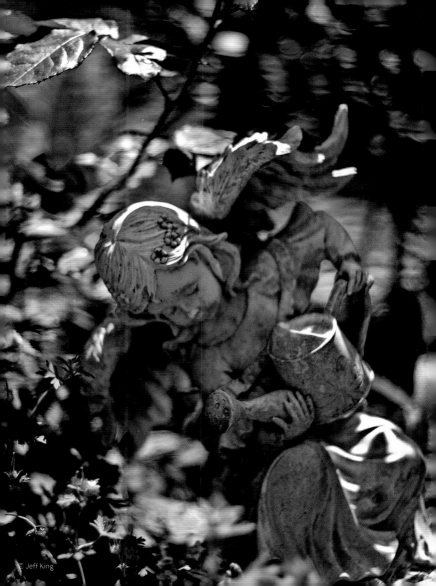

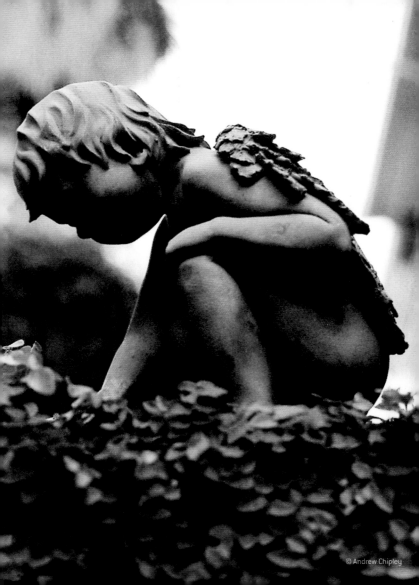
© Andrew Chipley

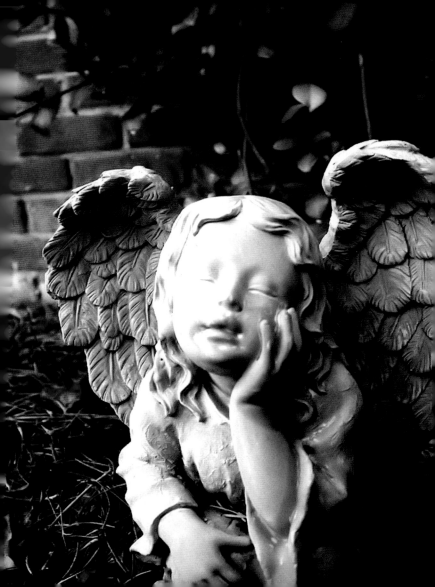

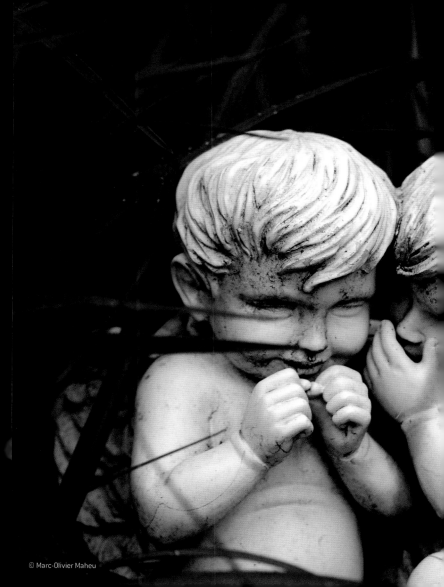

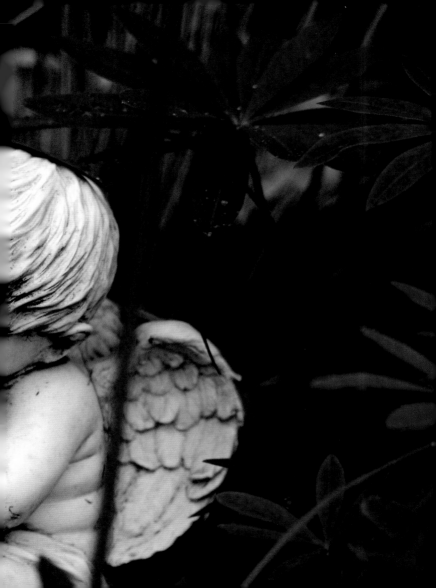

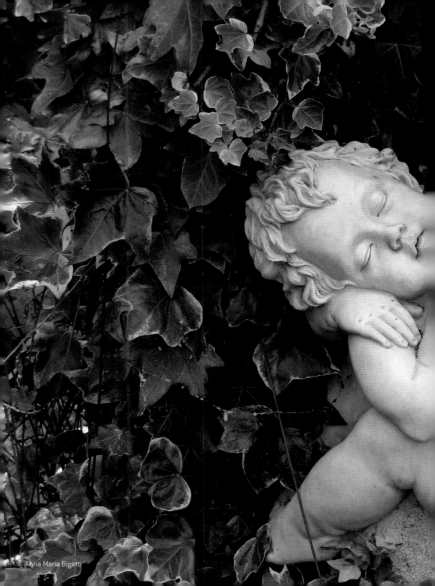

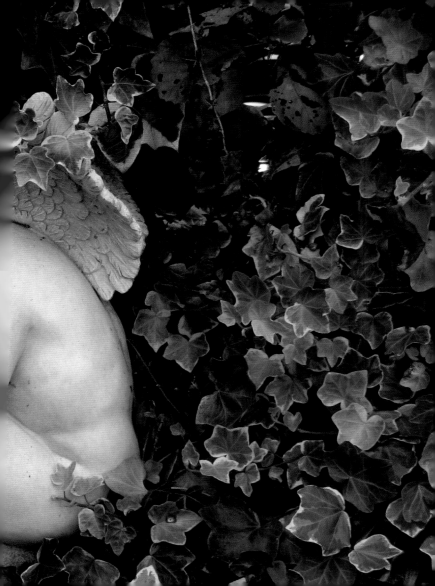

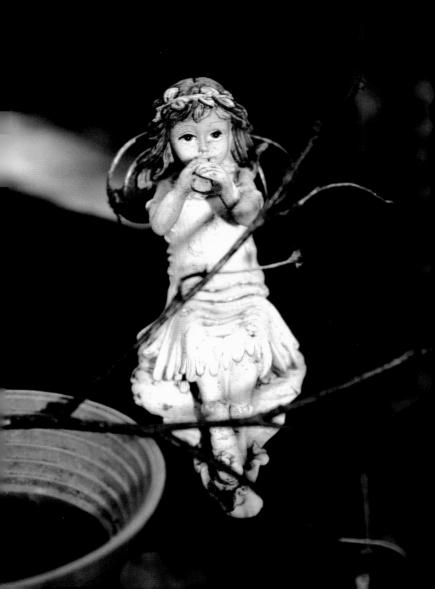

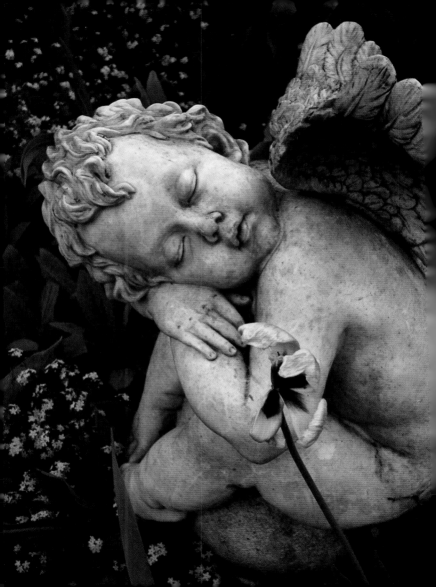

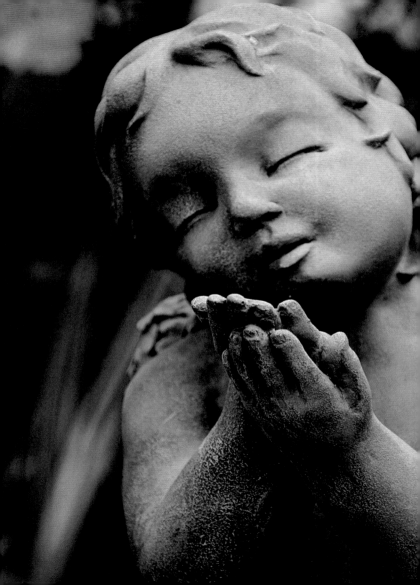

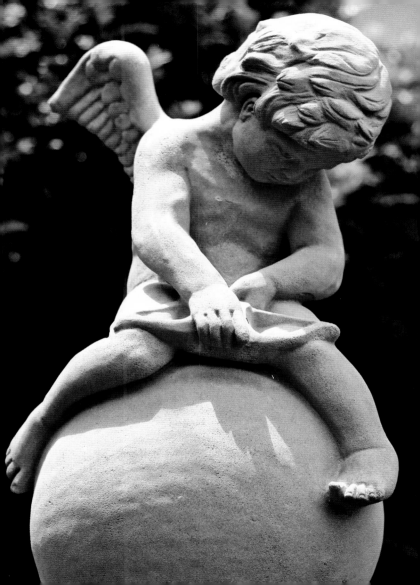

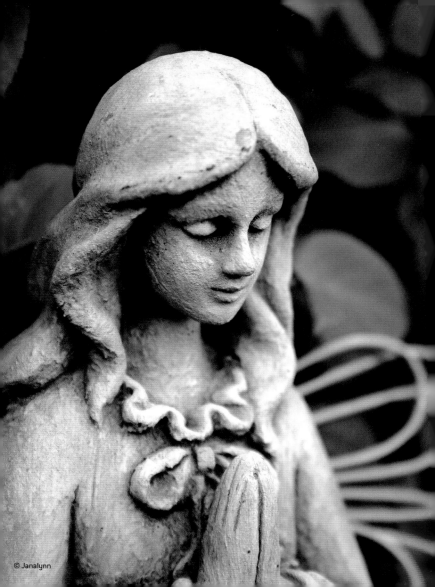

© Janalynn

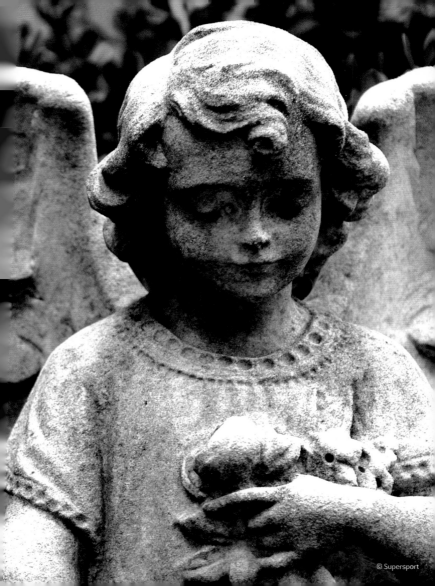

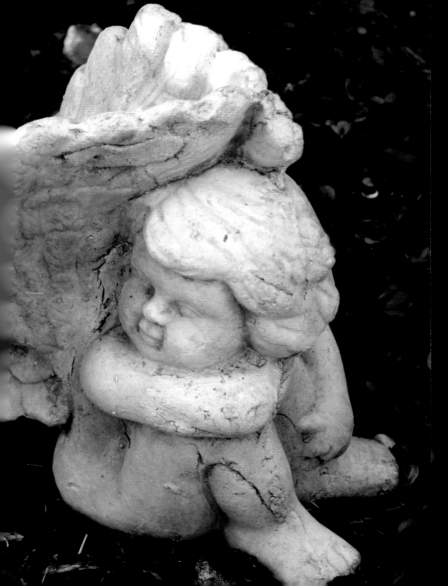

Jingle days

Jours de Noël

Weihnachtszeit

Kerstdagen

"Love came down at Christmas;
Love all lovely, love divine;
Love was born at Christmas,
Stars and angels gave the sign."

Christina G. Rossetti

« L'amour est descendu à Noël ;
Le bel amour, l'amour divin ;
L'amour est né à Noël ;
Les étoiles et les anges l'ont annoncé. »

Christina G. Rossetti

„Die Liebe kam an Weihnachten herab;
Die liebliche Liebe, göttliche Liebe;
Die Liebe wurde an Weihnachten geboren;
Sterne und Engel künden davon."

Christina G. Rossetti

"De liefde daalde neer met Kerstmis;
mooie liefde, goddelijke liefde;
De liefde werd geboren met Kerstmis,
De sterren en de engelen kondigden
het aan."

Christina G. Rossetti

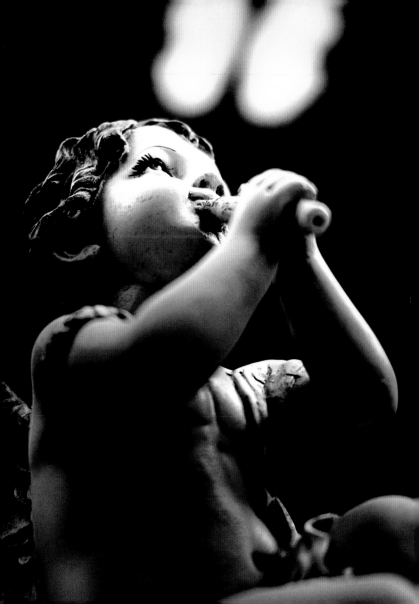

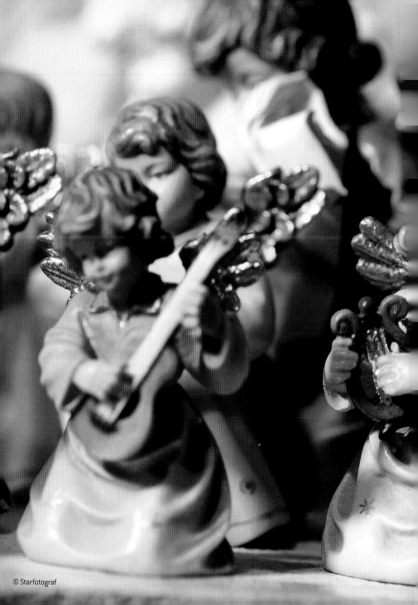
© Starfotograf

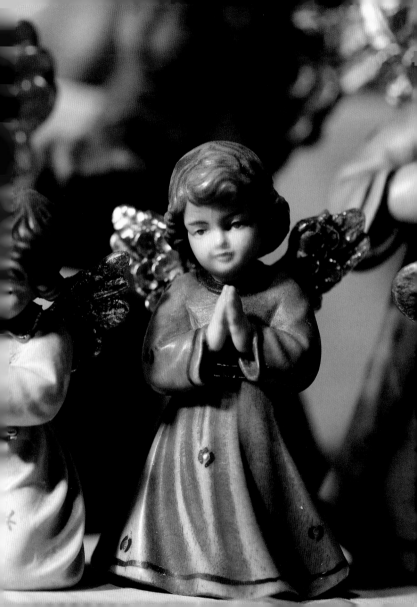

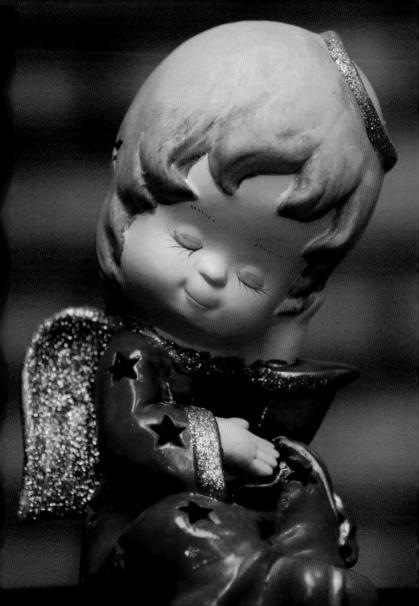

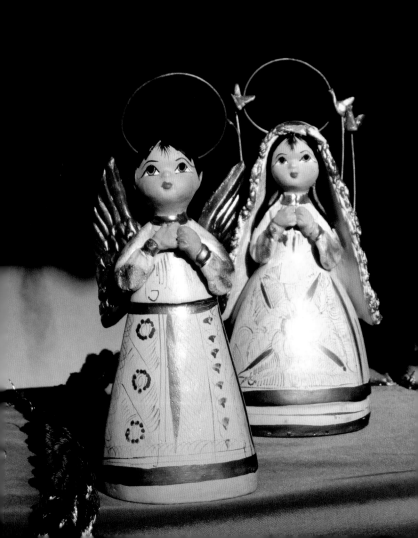

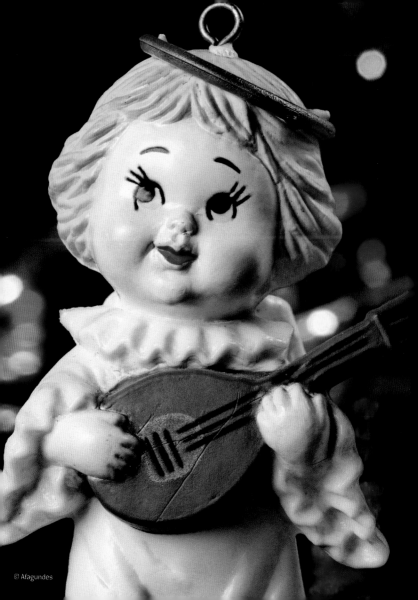

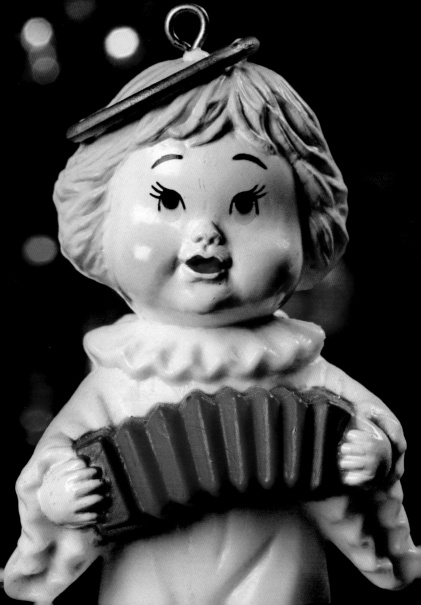

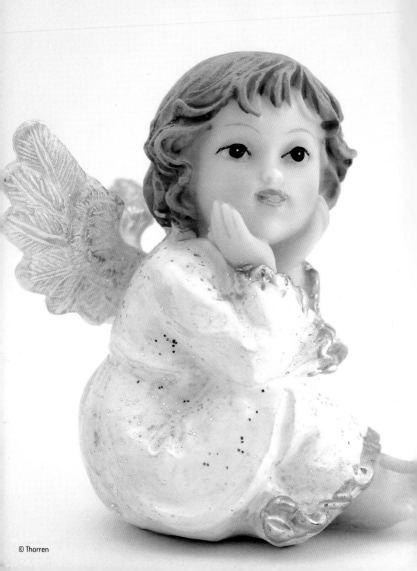

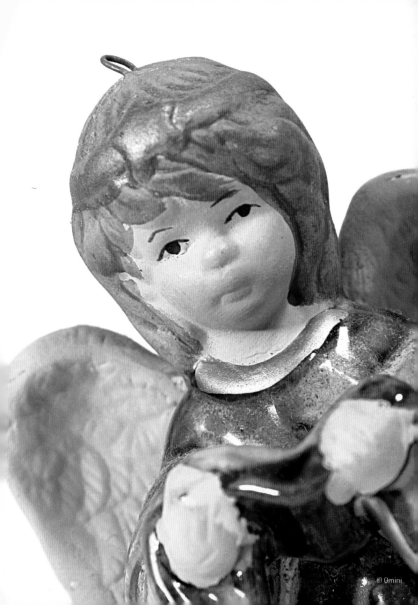

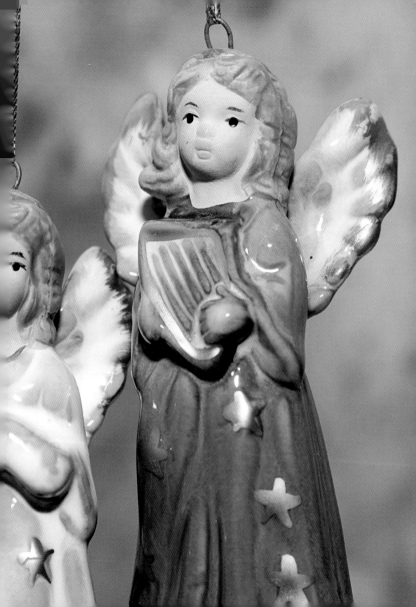

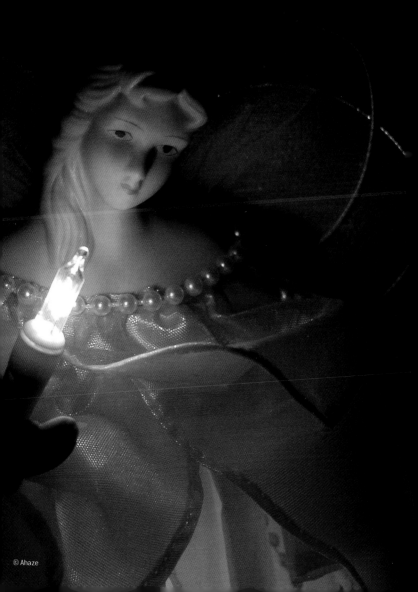

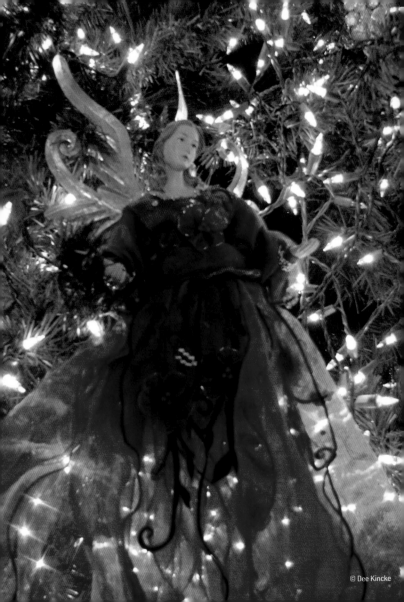

© Benettor

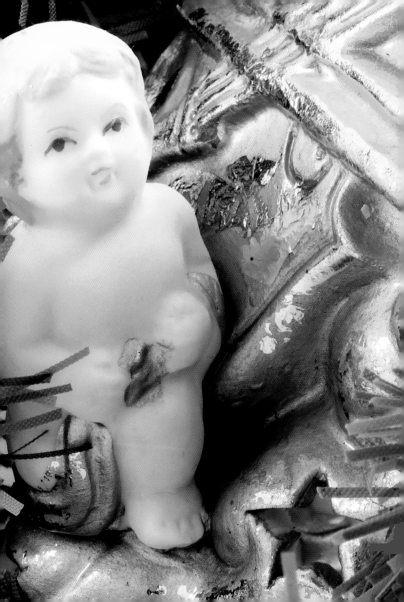

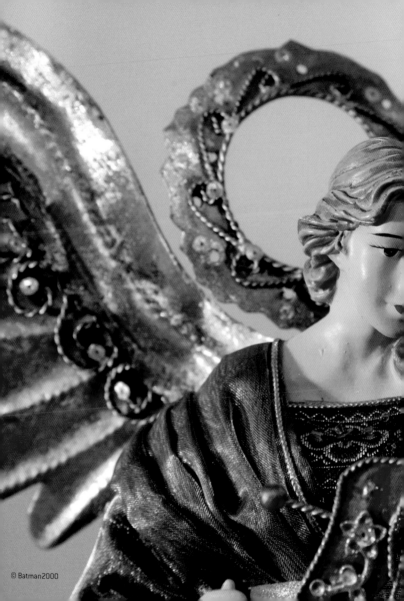

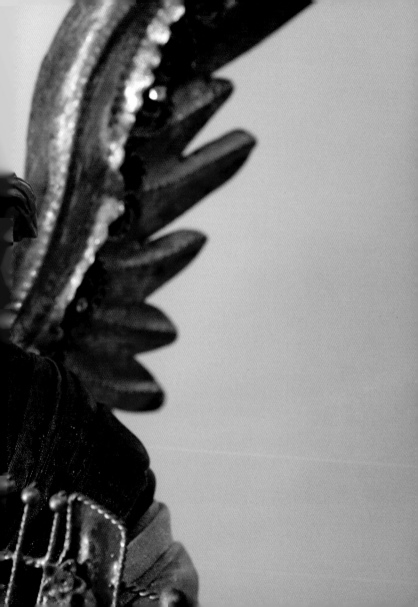

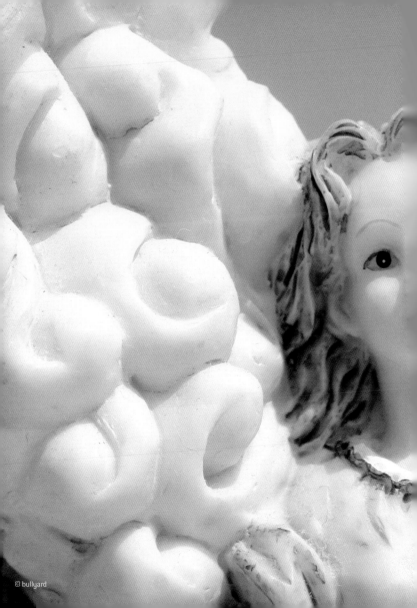

© bullyard

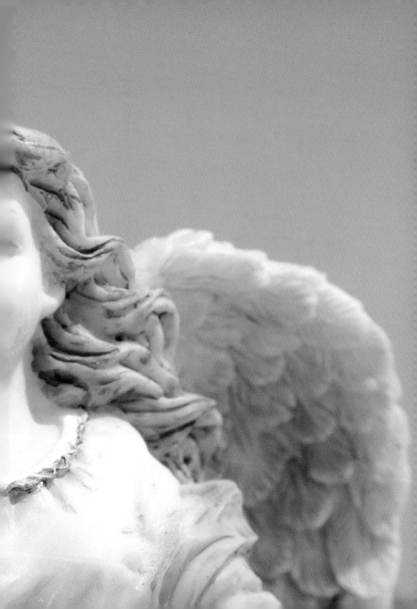

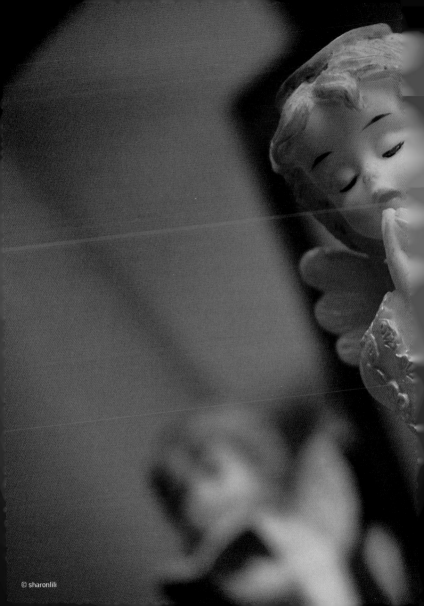

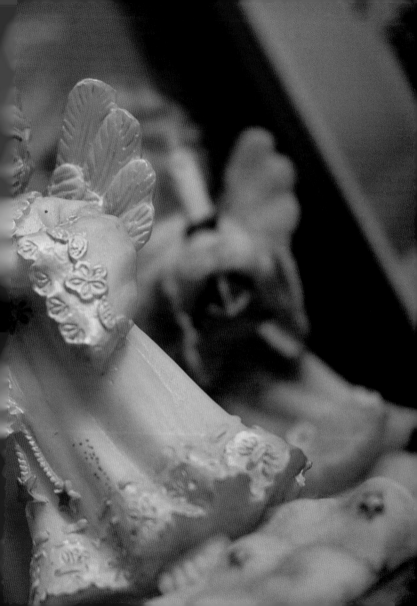

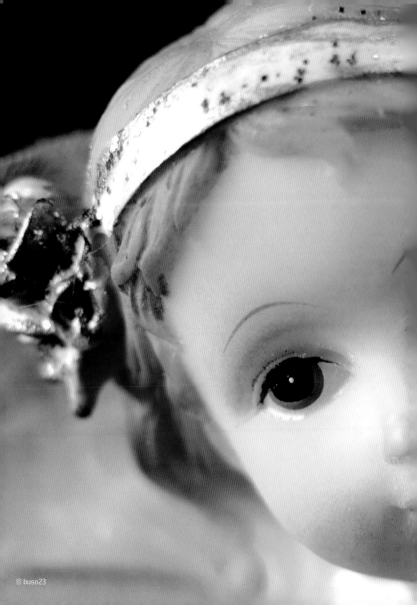

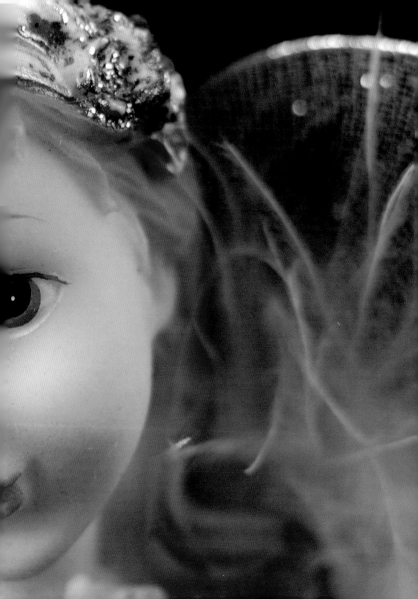

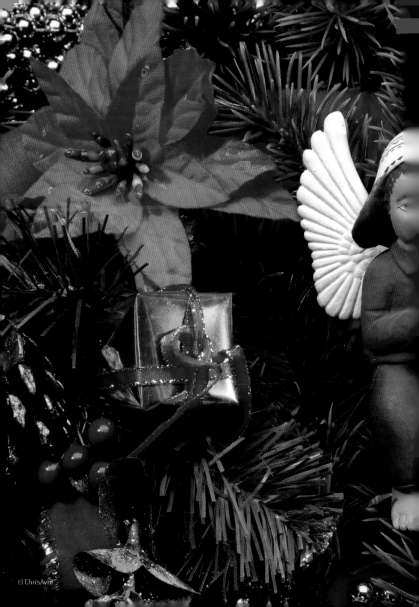

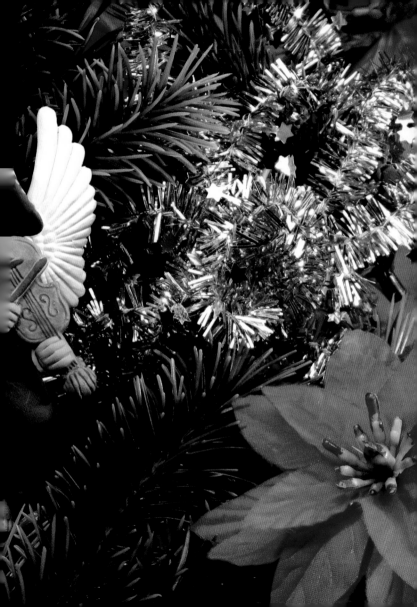

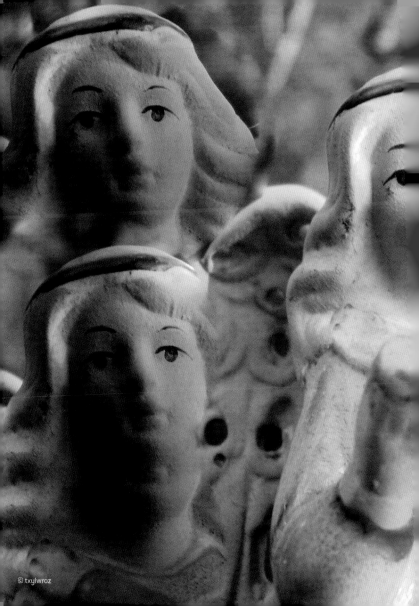

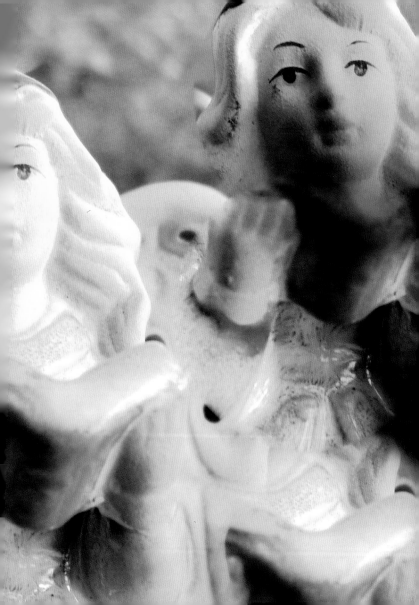

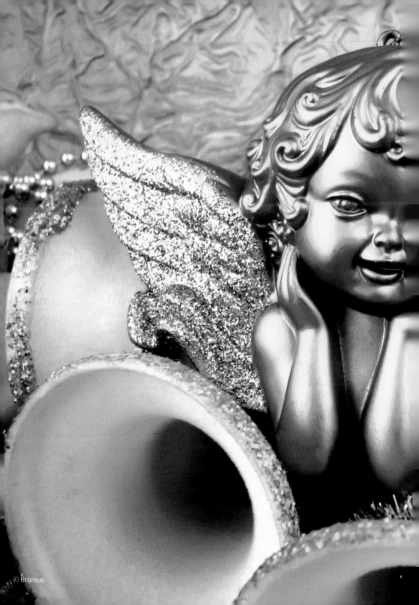

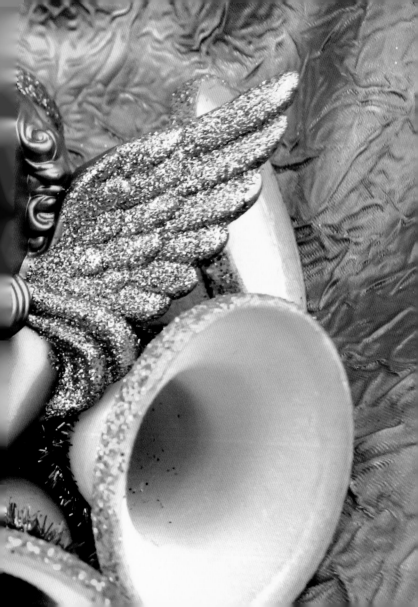

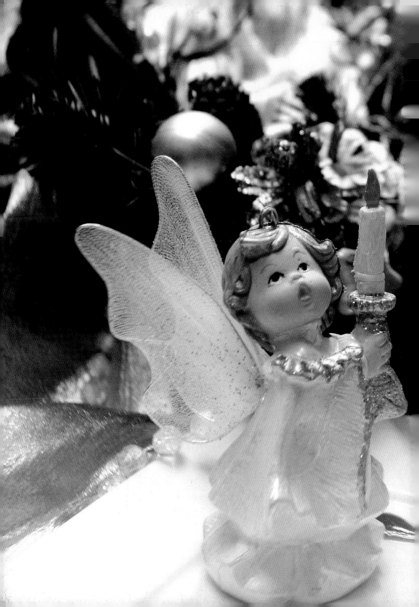

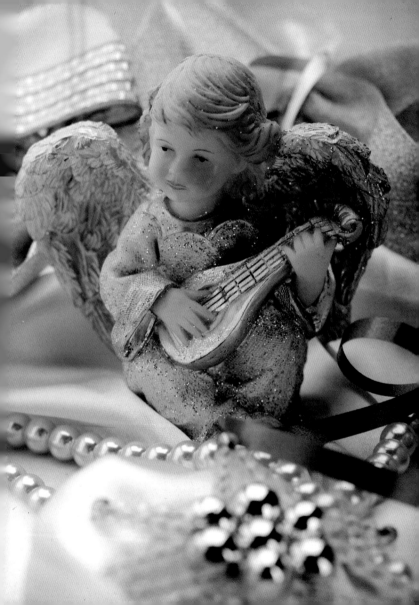

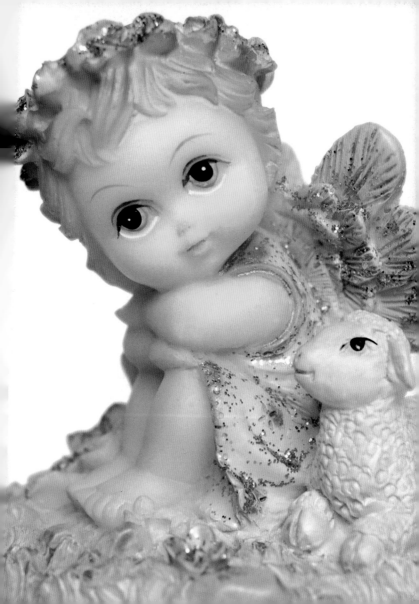

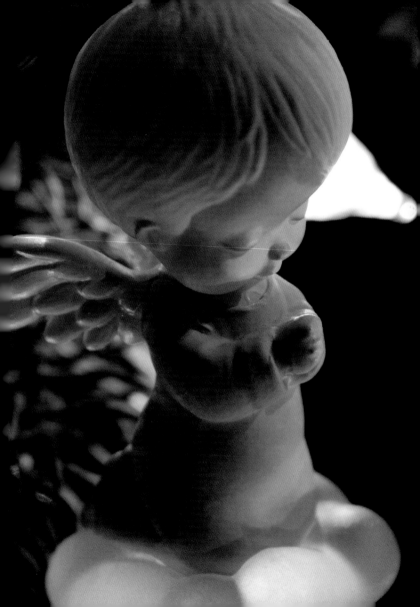

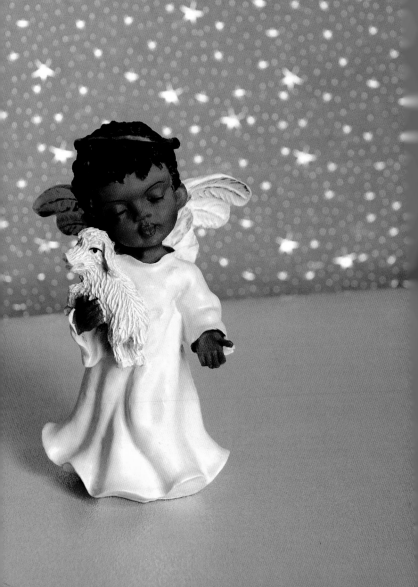

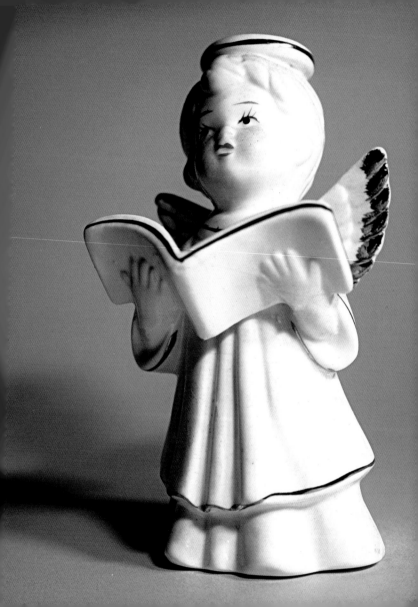

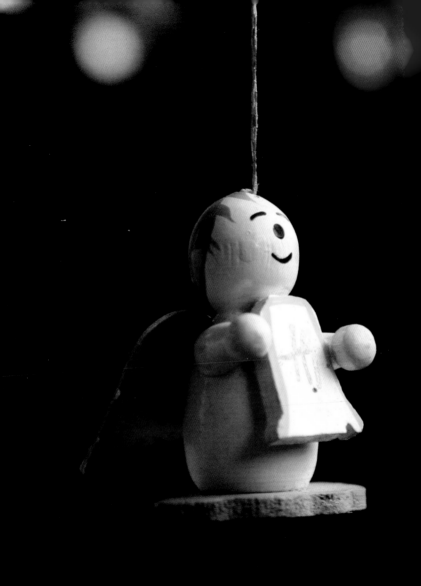

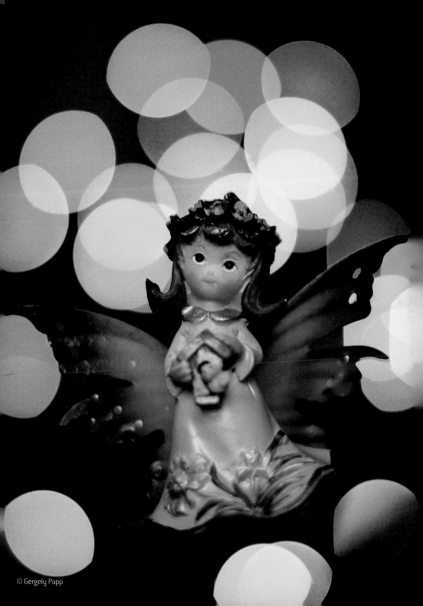

© Gergely Papp

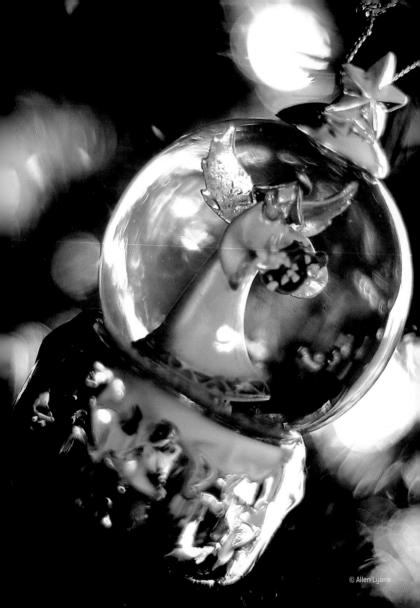

© Allen Lyons

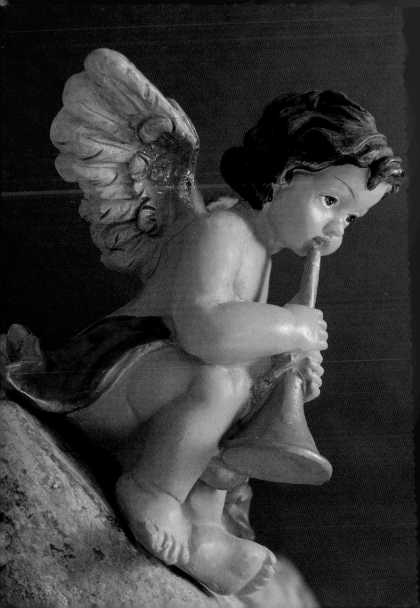

© Grapix

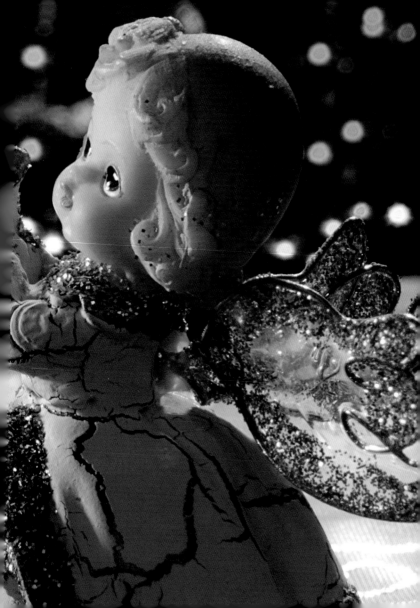

Up in the sky

Là-haut dans le ciel

Hoch im Himmel

In de hemel

miljoenen mensen erdoor worden aangetrokken, of het nu om een religieuze, esoterische of zuiver esthetische kwestie gaat.

Dit boek is een kleine catalogus met talrijke foto's van engelen die overal ter wereld genomen werden. Het boek is onderverdeeld in diverse hoofdstukken waarin poëtische afbeeldingen, foto's van kerkhoven, steden, religieuze tempels, tuinen en feesten bijeengebracht zijn. Deze bundel wil niet alleen een verzameling belichamingen van engelen zijn, maar eveneens een kleine gids van de verschillende gemoedstoestanden die met deze gevleugelde figuren gepaard gaan. Bovendien wordt elk hoofdstuk afgerond met korte gedichten of citaten van beroemde personen uit de literatuur en de filosofie.

Angels is een compendium van een fractie van de honderdduizenden gevleugelde figuren die wereldwijd verspreid zijn. Aartsengelen, cherubijnen, monumentale afbeeldingen en kleine beeldjes werden hier samengebracht zodat iedereen die door de magie van deze figuren wordt gefascineerd, of die simpelweg door nieuwsgierigheid gedreven wordt, zich kan verdiepen in de bijzondere wereld van het alledaagse mysterie. Ook al is het maar voor eventjes. Veel plezier ermee!

Noot:
Linnéa, Sharon. «Angels: History or Mistery?». 2002, http://www.beliefnet.com/Inspiration/Angels/2002/10/Angels-History-Or-Mystery.aspx?p=1

In de loop van de geschiedenis van de mensheid komen engelen in bijna alle culturen voor. Bij de Grieken wordt Hermes afgebeeld met vleugels aan zijn voeten. Ook op sommige Egyptische hiërogliefen zijn gevleugelde figuren te vinden, alsmede op Etruskische graftombes. Onder de Vikingen kregen voorstellingen met vleugels de naam Valkyries.

Vleugels zijn echter niet de kenmerkende eigenschap van engelen. In het Oude Testament nemen de bodes van God gewoonlijk een menselijke vorm aan en kunnen zij pas als engelen worden herkend nadat zij hun missie hebben volbracht. Hun voornaamste eigenschap is dan ook dat zij gezanten zijn. In feite is het woord "engel" afgeleid van *angelus*, wat letterlijk 'bode' betekent. Daarnaast betekent de Hebreeuwse term *malak*, die ook in de Heilige Schrift wordt gebruikt, 'afgevaardigde' of 'boodschapper'.

Het is interessant om te zien dat de moderne astrologie een evolutie van deze figuren voorstelt als energieke wezens met een veel hogere trillingsfrequentie dan de mens kan waarnemen. Volgens de *new age* overtuiging zou men evenwel dezelfde frequentie kunnen bereiken door middel van rituelen en gebed.

Maar afgezien van hun oorsprong, is het een feit dat het mysterie van de engelen in onze cultuur blijft voortleven. We kunnen ze zowel in grote steden als op afgelegen plekken afgebeeld zien. De twijfel over het ware bestaan van engelen neemt niet weg dat

wie an verborgenen Orten finden. Der Zweifel an ihrer realen Existenz verhindert nicht, dass sich Millionen Menschen von ihnen angezogen fühlen, entweder aus religiösen, esoterischen oder rein ästhetischen Gründen.

Dieses Buch ist ein kleiner Katalog verschiedener Fotographien von Engeln, die rund um die Welt aufgenommen wurden. Unterteilt in verschiedene Kapitel, in denen poetische Bilder von Friedhöfen, Städten, Kirchen, Gärten und Festen zusammengestellt sind, will der Band nicht nur eine Sammlung von Darstellungen sein, sondern auch ein kleiner Führer durch die verschiedenen Gemütsverfassungen, die mit dem Betrachten dieser geflügelten Gestalten einhergehen. Dazu wird jedes Kapitel durch kurze Gedichte oder Zitate berühmter Persönlichkeiten aus Literatur und Philosophie ergänzt.

So ist *Angels* ein Kompendium eines Teils von Hunderttausenden von geflügelten Gestalten, die sich über die ganze Welt verstreut finden. Erzengel, Cherubine, monumentale Bilder und Statuetten sind hier vereint, damit alle, die vom Zauber der Engel fasziniert oder einfach von ihrer Neugierde geleitet sind, wenn auch nur für kurze Momente, in diese besondere Welt des täglichen Mysteriums eintauchen können. Wir wünschen Ihnen viel Vergnügen!

Fußnote:
Linnéa, Sharon. „Angels: History or Mystery?" 2002, http://www.beliefnet.com/ Inspiration/Angels/2002/10/Angels-History-Or-Mystery.aspx?p=1

Im Lauf der Menschheitsgeschichte kommen Engel in fast allen Kulturen vor. Bei den Griechen wird Hermes mit Flügeln an den Füßen abgebildet. Auch in einigen ägyptischen Hieroglyphen und in etruskischen Gräbern kann man geflügelte Gestalten erkennen. Bei den Wikingern erhielten die Darstellungen mit Flügeln den Namen Walküren.

Es sind jedoch nicht ihre Flügel, die die Engel definieren. Im Alten Testament nehmen die Sendboten Gottes gewöhnlich menschliche Gestalt an und werden erst als Engel erkannt, wenn ihre Mission erfüllt ist. Folglich ist ihre Haupteigenschaft die eines Gesandten. Tatsächlich leitet sich das Wort „Engel" von *angelus* ab, was wörtlich „Bote" bedeutet. Zudem bedeutet der hebräische Begriff *malak*, der auch in der Heiligen Schrift gebraucht wird, „Delegierter" oder „Botschafter".

Es ist interessant, festzustellen, dass sich diese Figuren in der modernen Astrologie zu energetischen Wesen entwickelt haben, die in einer Frequenz schwingen, welche viel höher ist als diejenige, die wir Menschen wahrnehmen können. Die Anhänger der New-Age-Religionen verfechten jedoch die Meinung, dass man mit Hilfe von Ritualen und Gebet auf deren Frequenz kommen kann.

Jenseits der Frage nach ihrem Ursprung ist jedoch sicher, dass das Mysterium der Engel bis heute in unserer Kultur lebendig ist. Wir können ihre Darstellungen in großen Städten ebenso

n'empêche pas des millions de personnes de se sentir attirées par eux, que ce soit pour un motif religieux, ésotérique, ou purement esthétique.

Ce livre est un petit catalogue des différentes photographies d'anges prises dans le monde entier. Organisé autour de différents chapitres qui rassemblent des images poétiques de cimetières, de villes, de temples religieux, de jardins et de fêtes, ce volume se veut non seulement un recueil de représentations, mais aussi un petit guide des différents états d'esprit qui accompagnent ces figures ailées. De plus, chaque chapitre est accompagné de courts poèmes ou de citations d'écrivains et de philosophes célèbres.

Ainsi, *Angels* est un précis de quelques-unes des centaines de milliers de représentations ailées que l'on trouve de par le monde. Archanges, chérubins, images monumentales et petites statuettes se trouvent ici réunis pour que tous ceux qui se sentent fascinés par leur magie, ou simplement guidés par la curiosité, puissent se plonger dans le monde particulier du mystère quotidien. Même si ce n'est que l'espace de quelques instants. Nous espérons que vous apprécierez !

Note :
Linnéa, Sharon. « Angels: History or Mystery ? ». 2002, http://www.beliefnet.com/Inspiration/Angels/2002/10/Angels-History-Or-Mystery.aspx?p=1

Au cours de l'histoire de l'humanité, les anges ont existé dans presque toutes les cultures. Chez les Grecs, Hermès est représenté avec des ailes aux pieds. On peut aussi apercevoir des figures ailées sur certains hiéroglyphes égyptiens, ainsi que dans les tombes étrusques. Chez les Vikings, les personnages avec des ailes portaient le nom de valkyries.

Ce n'est pourtant pas le fait qu'ils soient ailés qui définit les anges. Dans l'Ancien Testament, les envoyés de Dieu adoptent bien souvent forme humaine, et ne sont reconnus comme anges qu'une fois leur mission accomplie. Ainsi leur principale caractéristique c'est d'être des envoyés. En effet, le mot « ange » vient d'*angelus*, dont la signification exacte est « messager ». Et le terme hébreu *malak*, qui apparaît également dans les Saintes Écritures, signifie « délégué » ou « ambassadeur ».

Il est intéressant d'observer que l'astrologie moderne propose une évolution de ces personnages comme des êtres énergétiques qui vibrent à une fréquence bien supérieure à celle que les humains sont capables de percevoir. Cependant, les croyances *new age* affirment que, grâce aux rituels et à la prière, on pourrait parvenir à s'accorder sur la même fréquence fn qu'eux.

Mais au-delà de ses origines, ce qui est certain c'est que le mystère des anges reste bien vivant dans notre culture. On peut en découvrir des représentations aussi bien dans les grandes villes que dans des lieux retirés. Le doute sur leur existence réelle

This book is a small collection of different photographs of angels taken all over the world. Organized into different chapters that bring together poetic images of cemeteries, cities, religious temples, gardens, and festivals, this book aims not only to be a catalogof illustrations, but also a small guide to the various states of mind that accompany these winged creatures on their flight. In addition, each chapter is complemented with short poems or quotations by famous characters from the world of philosophy and literature.

Angels is a compendium of a part of the hundreds of thousands of winged figures scattered around the world. Archangels, cherubs, monumental images, and tiny figurines are all brought together here so that anyone who is fascinated by their magic, or simply guided by their own curiosity, can immerse themselves in a private world of unresolved mystery, even if only for a short while. We hope enjoy it!

Note:
Linnéa, Sharon. Angels: History or Mystery? 2002, http://www.beliefnet.com/Inspiration/Angels/2002/10/Angels-History-Or-Mystery.aspx?p=1

Throughout human history, angels have existed in nearly every culture. The Greeks depicted Hermes with wings on his heels. Winged figures can also be seen in some Egyptian hieroglyphics, and also on Etruscan tombs. For the Vikings, creatures depicted with wings were known as valkyries.

However, it is not the having wings that really defines an angel. In the Old Testament, the envoys of God tend to adopt a human form and are only recognized as angels once their mission is over. Thus, their main characteristic is that of being envoys. In fact, the word 'angel' is derived from *angelus*, which literarily means 'messenger'. Furthermore, the Hebrew term *malak*, also used in the Holy Scriptures, means 'delegate' or 'ambassador'.

It is interesting to see that modern astrology proposes an evolution of these figures as energetic beings vibrating at a frequency that is much higher than the levels human beings are able to perceive. Nevertheless, *new age* beliefs hold that it might be possible to tune into the same frequency through rituals and prayer.

But regardless of what their origin might be, the mystery of the angels is very much alive in our culture. Representations of them are to be found in large cities and also in hidden away places. Doubts about their existence do not stop millions of people from feeling drawn to them, whether on religious grounds, or esoteric or purely aesthetic ones.

CONTENTS

ANGELS

ANGES | ENGEL | ENGELEN

booQs

© 2009 **booQs** publishers bvba
Godefriduskaai 22
2000 Antwerp
Belgium
Tel: +32 3 226 66 73
Fax: +32 3 226 53 65
www.booqs.be
info@booqs.be

ISBN: 978-94-60650-01-7
WD: D/2009/11978/002
(Q002)

Editor & texts: Paz Diman
Art direction: Mireia Casanovas Soley
Design and layout coordination:
Emma Termes Parera
Translation: Cillero & De Motta Traducción

Editorial project:

maomao publications
Via Laietana, 32, 4.º, of. 104
08003 Barcelona, Spain
Tel.: +34 932 688 088
Fax: +34 933 174 208
maomao@maomaopublications.com
www.maomaopublications.com

Printed in China

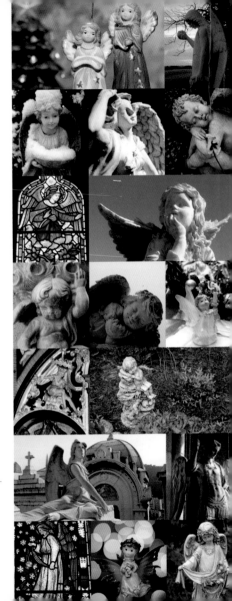

ANGELS

ANGES | ENGEL | ENGELEN